MORPHOSIS RECENT PROJECT

Edited by Yukio Futagawa

Copyright © 2010 A.D.A. EDITA Tokyo Co., Ltd.
3-12-14 Sendagaya, Shibuya-ku, Tokyo 151-0051, Japan
All rights reserved. No part of this publication may be reproduced,
stored in a retrieval system, or transmitted,
in any form or by any means, electronic, mechanical,
photocopying, recording, or otherwise,
without permission in writing from the publisher.

Copyright of photographs except as noted
© 2010 GA photographers
Copyright of drawings and renderings
© 2010 Morphosis Architects

Printed and bound in Japan

ISBN 978-4-87140-671-0 C1052

MORPHOSIS
RECENT PROJECT

A.D.A. EDITA Tokyo

RECENT PROJECT
MORP

HOSIS

Contents		目次	
Giant Group Campus Shanghai, China	8	ジャイアント・グループ・キャンパス 中国，上海	
Interview Friday, October 22, 2010 : 10:00 am / Tokyo Thom Mayne/Morphosis	36	インタヴュー 2010年10月22日金曜日：午前10時／東京 トム・メイン／モーフォシス	
University of Chicago Center for Creative and Performing Arts Chicago, Illinois, U.S.A.	46	シカゴ大学創造・舞台芸術センター アメリカ，イリノイ州，シカゴ	
New Orleans National Jazz Center New Orleans, Louisiana, U.S.A.	52	ニューオリンズ国立ジャズ・センター アメリカ，ルイジアナ州，ニューオリンズ	
Phare Tower La Défense, France	58	ファール・タワー フランス，ラ・デファンス	
Kuala Lumpur Towers Kuala Lumpur, Malaysia	66	クアラルンプール・タワーズ マレーシア，クアラルンプール	
Taipei Performing Arts Center Taipei, Taiwan, R.O.C.	72	台北舞台芸術センター 台湾，台北	
Seoul Performing Arts Center Seoul, South Korea	78	ソウル舞台芸術センター 韓国，ソウル	
Perot Museum of Nature & Science Dallas, Texas, U.S.A.	86	ペロー自然科学博物館 アメリカ，テキサス州，ダラス	

Emerson College Los Angeles Center Los Angeles, California, U.S.A.	94	エマーソン・カレッジ・ロサンジェルス・センター アメリカ，カリフォルニア州，ロサンジェルス	
King Abdullah Petroleum Studies and Research Center Riyadh, Saudi Arabia	100	アブドラ王石油調査研究センター サウジアラビア，リヤド	
Four Towers in One Competition Shenzhen, China	107	4タワーズ in 1 コンペティション 中国，深圳	
New U.S. Embassy in London London, U.K.	114	在ロンドン新アメリカ大使館 イギリス，ロンドン	
Taipei Pop Music Center Taipei, Taiwan, R.O.C.	118	台北ポップミュージック・センター 台湾，台北	
Shanghai Linkong Plot 15 Concept Design Shanghai, China	126	上海臨空街区15コンセプト・デザイン 中国，上海	
Kaohsiung Maritime Cultural and Popular Music Center Kaohsiung, Taiwan, R.O.C.	134	高雄海洋文化・ポップミュージック・センター 台湾，高雄	
Columbia University Medical Center Campus New York, New York, U.S.A.	142	コロンビア大学メディカル・センター・キャンパス アメリカ，ニューヨーク州，ニューヨーク	
Cornell University, Computing and Information Science Building Ithaca, New York, U.S.A.	154	コーネル大学コンピュータ情報科学棟 アメリカ，ニューヨーク州，イサカ	
Profile/List of Projects	158	プロフィール／プロジェクト・リスト	

Cover
Giant Group Campus
photo by Yoshio F.

Title pages
Taipei Performing Arts Center
photo by Michael Powers

Giant Group Campus

Design: 2005–06 Construction: 2006–10 Shanghai, China Photos: Yoshio F.

Overall view: West campus (left) and East campus (right)　全景：西キャンパス（左）と東キャンパス（右）

View from southeast toward East campus　南東より東キャンパスを見る

Driveway to main entrance　メイン・エントランスへ続くドライブウェイ

Site plan

1	ENTRANCE
2	EXHIBITION HALL
3	CAFE
4	AUDITORIUM
5	LIBRARY
6	ZHONGKAI ROAD
7	FITNESS CENTER
8	INDOOR SWIMMING POOL
9	HOTEL RECEPTION
10	GLASS FLOOR HOTEL ROOMS
11	BAR
12	PARKING
13	OPEN OFFICE
14	CEO AREA
15	GREEN ROOF
16	PRIVATE OFFICE
17	LAKE
18	POND

The Giant Campus project is a compact village that accommodates diverse functions in a flexible framework of forms that move in and out of a folded landscape plane. Situated amid existing canals and a new man made lake, the undulating office building interacts with an augmented ground plane, joining architecture to landscape and environment to site. The East Campus office building contains three zones: open, non-hierarchical office space; private offices, and executive suites, which cantilever dramatically over the lake. Additional program is integrated into the lifted landscape, including a library, an auditorium, an exhibition space, and a cafe on the east campus. On the West Campus, additional program space-submerged below an expansive, undulating green roof-includes a pool, a multi-purpose sports court, and additional relaxation and fitness spaces for employees. The landform culminates to the west at a company guest hotel where glass-floored private bedroom suites project over a wildlife pond.

Several plazas, carved from the landscape, provide outdoor break and recreational spaces for employees. At the south edge of the campus, a pedestrian plaza steps down to the water's edge in a continuous outdoor walkway that provides pedestrian access to the lake. The main circulation spine, an enclosed walkway located outboard of the office building, bridges over the street connecting the east and west campuses.

A range of features on the project maximize both energy efficiency and occupant comfort. The West Campus's landscaped green roof provides thermal mass that limits the heat gain and reduces cooling expenditures. The facade's double skin and insulated glass curtain wall minimize solar heat gain and improve overall efficiency. The central circulation spine, along with the recreational amenities and plazas provide opportunities for chance encounters and places for employees to gather without the confines of cubicles or unnecessary divisions. The narrow profile of the office building combined with a system of skylights ensure that employees have continuous access to natural daylight.

Second floor

First floor

Ground floor

ジャイアント・キャンパス・プロジェクトは，褶曲したランドスケープ平面から出入りするフレキシブルな形態構成に，多様な機能を集約的に収容したヴィレッジである。既存運河と新しい人造湖の直中に位置し，起伏に富んだオフィス棟は，拡張された地盤面と相互に作用しあうことで，建築をランドスケープへ，また，環境を敷地へと結びつけている。東キャンパスのオフィス棟には3区画が内包される。ヒエラルキーのない開放されたオフィス空間，専用オフィス，および重役室が，湖の上に大きく跳ね出している。図書館，オーディトリアム，展示スペース，および東キャンパスに面したカフェといった付加的なプログラムは，空中に浮かぶランドスケープの内部に統合されている。西キャンパスの付加的なプログラムには——広々として起伏に富んだ緑の屋根の下に覆い隠されている——プール，多目的スポーツ場，従業員用のレクリエーション及びフィットネス施設がある。この地形は西に向かって来賓用ホテルのところで終わり，ガラス床張りのプライベート・スイートルームが自然の池の真上に突き出している。

ランドスケープ上に造られた幾つかの広場は，従業員のための屋外休憩用レクリエーション施設となっている。キャンパス南辺の歩行者用広場からは，水面の際まで続く屋外通路を下ってゆくことで，湖まで歩いて行くことができる。脊柱をなす主要動線，すなわちオフィス棟外部に位置する屋内通路は，大通りを越えて東西のキャンパスをつないでいる。

このプロジェクトにはエネルギー効率と居住者の快適性を最大化する多様な特徴がある。植栽された西キャンパスの緑の屋根が供給する熱質量は，熱取得を制限し，冷房コストを削減している。ファサードの複層断熱ガラスのカーテンウォールは太陽熱取得を最小化し，熱効率を全面的に向上させている。レクリエーション用の施設や広場に加えて脊柱をなす中央の動線は，従業員同士が偶然に出会い，あるいは個室に閉じこもり不必要に区画されることなく従業員同士で集まることのできる場所を提供する。幅の狭いオフィス棟の断面形状は，天窓の機構と共に，従業員のため，常に自然の陽光を確保している。

Sections

△▽ *South view*　南より見る

West view: office volume of East campus over lake　西より見る：東キャンパス，湖の上のオフィス・ヴォリューム

Structure

North elevation of East campus 東キャンパス，北より見る

Structure

△▽ *Northeast view of East campus* 東キャンパス：北東より見る

Exploded diagrams

Street under the building: West campus (left) and East campus (right)　建物の下を抜ける道路：左は西キャンパス，右は東キャンパス

View toward East campus: bridge of walkway over road　東キャンパスを見る：道路上の橋状の通路

Volume of auditorium　オーディトリウムのヴォリューム

South view　南より見る

Cafe in East campus △▽
東キャンパスのカフェ

△▽ *Entrance of East campus*　東キャンパス・エントランス

Entrance エントランス

View toward entrance on West campus
西キャンパスのエントランスを見る

Entrance of West campus　西キャンパス，エントランス

Bar in West campus 西キャンパス，バー

Entrance hall of West campus　西キャンパス，エントランス・ホール

Fitness center　フィットネス・センター

28

Hotel reception ホテル・レセプション△▽

29

Swimming pool in West campus　西キャンパス，スイミング・プール

Swimming pool スイミング・プール

Bridge over swimming pool
スイミング・プール上のブリッジ

33

Evening view of East campus　東キャンパス夕景

Executive office in East campus　東キャンパス，エクゼクティブ・オフィス

Interview
Friday, October 22, 2010 : 10:00 am / Tokyo
Thom Mayne / Morphosis

2010年10月22日金曜日：午前10時／東京
トム・メイン／モーフォシス

Thom Mayne

Vienna Expo '95 Competition

GA: Could you tell me about your Giant Group Campus project in Shanghai?

Thom Mayne (TM): In some ways, the Giant project is a culmination of two concepts I've been interested in since the mid-eighties: the integration of landscape with architecture and the use of combinatory form as an operational strategy to create a building.

GA: Can you tell me about this interest and how it has developed over the last twenty five years?

TM: We did a competition for the Vienna Expo '95 Competition. The site was interstitial, between the river and the U.N. complex. We made a decision to locate much of the program within the ground. I don't know if you remember it.

GA: Yes.

TM: We rethought the idea of the relationship between figure and ground and developed an idea of an augmented landscape that would be active, comprised of programmatic material. This investigation unleashed a new kind of thinking for us.

GA: So it really began with an investigation of the ground as a defining force?

TM: Yes. Right after that, we were invited by Kristin Feireiss for a competition in Paris (Paris et Utopie, a project on the Seine). We explored a similar strategy, working with the idea of a fusion of a land-water boundary as a connective tissue.

The water-groundscape notion gave rise to our interest in an ambiguous interconnectivity; in breaking down boundaries....a more seamless connection.

GA: So with these two projects from the late 1980's you began to study the connections between earth and buildings?

TM: No. We actually worked with this idea in an earlier house in Santa Barbara (Crawford Residence). At that time we were looking at Michael Heiser and a few other earth artists; I had already been out to Double Negative.

GA: Oh yes, the earthwork sculpture in Nevada, with two long, deep trenches cut into the land.

TM: Exactly. And then through a show at Leo Castelli Gallery, I became aware of (Walter) Pichler, who was a digger and of Raimund Abraham's work—both of which were influential.

GA: Both Austrian architects, I believe.

TM: Yes. Raimund passed away recently; at his memorial I gave a talk about his contributions. In Raimund's work, I immediately understood his relationship to the earth, which in his case is a very symbolic, almost religious connection.

GA: So you are really researching earth connections during this time.

TM: I was certainly taking it in; I don't think I fully understood it to be as influential as it actually was.

GA: So where did these ideas first start to manifest in your architecture?

TM: With the Crawford house, it was all about land markings. Although it was still planometric, it was quite different from what we are doing now; there was essentially no building *per se*. The site was now the generative material, the initiator of the design process....the idea of scratching, digging in the ground and making the earth occupiable.

GA: This contact with the earth began as a kind of primal connection?

TM: You can look at that project and you can see that we were struggling. We tried to get it into the ground, to make walls and totems; variable rhythmic events that cross the site. At the same

GA：上海のジャイアント・グループ・キャンパスについてお話し頂けますか？

トム・メイン（TM）：私にとってジャイアント・プロジェクトは，一つにはランドスケープの建築への統合，もう一つは建築を生み出すために複合的形態を戦略的方法論に応用することといった，ある意味，80年代中頃から抱き続けてきた二つの関心の集大成です。

GA：その関心について，また，この25年間でそのような関心をどう深められたのか，お話頂けますか？

TM：「ウィーン・エキスポ'95」のコンペに参加した時のことです。ここは河川と国連事務所の隙間の敷地でした。私たちはプログラムのほとんどを地中に配置しようと考えました。覚えてはいらっしゃらないかもしれませんが。

GA：覚えています。

TM：私たちは図と地の関係性といった概念について再検討を行い，ランドスケープという概念を拡張し，これを能動的なもの，プログラム可能な素材によって構成されるものとして取り扱いました。この時の研究が，私たちに全く新しい考え方をもたらしました。

GA：つまり，土地が空間を規定する，そのような力学に関する研究がそもそもの始まりだと？

TM：その通りです。そのすぐ後に，クリスティン・ファイライスからパリのコンペ（「パリとユートピア」：セーヌ川沿いの計画）に招かれました。ここでも同様の方法論を発展させて，連続した組織体として陸―水の境界線を融合するという考え方に取り組みました。境界を解体し，より滑らかな関係をつくる。ウォーター・グラウンドスケープという概念が，多義的な相互関連性への関心を引き出したのです。

GA：つまり1980年代後半のこれら二つのプロジェクトを通して，土地と建築との関係についての研究を始められた？

TM：いや，実際にこの概念に取り組んだのはサンタ・バーバラの初期の住宅「クロフォード邸」です。この頃はマイケル・ハイザーや，他の数人のアースワークの芸術家に着目していました。ダブル・ネガティブを見に行ったりもしていました。

GA：確か2本の長くて深い溝を大地に刻んだネバダ州のアースワークの彫刻ですね。

TM：その通りです。それからレオ・キャステリ・ギャラリーの展覧会で，坑夫でもあったワルター・ピッヒラー，それとライムンド・アブラハムの作品について知るようになりました――二人の影響は私にとってとても大きいものです。

GA：二人とも確かオーストリアの建築家ですね。

TM：ええ。最近ライムンドが亡くなった時，追悼式で彼の芸術への貢献についてスピーチを行いました。ライムンドの作品を見ると，彼と大地との関係性がすぐに分かります。特に彼の場合は非常に象徴的，宗教的といってもよいほど大地と強く結びついていました。

GA：つまりこの頃に，土地との結びつきについての研究を実際に進められたと。

TM：その通りです。これほどまで影響力のあるものだとは，当時はまだよく分かってはいませんでしたが。

GA：これらの思想がご自身の建築にはっきりと現れてきたのはいつ頃ですか？

TM：「クロフォード邸」です。土地とは何か。これが全てでした。この頃は依然として平面斜投影図的でした。私たちの現在のやり方とは全く異なっています。基本的には建築というものがない。敷地こそが，何かを生み出す素材，設計プロセスの起爆剤でした……地面を掘り込むことで，その土

△▽ *Crawford Residence, Montecito, Santa Barbara, 1987-91*

Axonometric of Crawford Residence

Chiba Golf Club, Chiba (JPGA), 1991

time, the clients were pushing for a more conventional notion of house. The result was a hybrid that, in hindsight, is revealing of things to come. It was a big house, but it looked very modest from the street because it was pushed into a down-sloping hill; what you see is not the house, but a curved wall which reads as a landscape element. We were moving towards a hybridized idea of landscape, groundscape, and architecture.

GA: So how did your ideas about the groundscape continue to develop from here?

TM: Well, right after that we were interviewed and got the job for JPGA (Chiba Golf Clubhouse in Japan). The influence of Crawford on JPGA is completely obvious. With JPGA, we moved further into the ground, into an earth-cutting operation.

GA: Back to the connection with the earth artists from the late sixties and early seventies.

TM: For JPGA, we intentionally left one element as the counterpoint....a singular building in the traditional realm of architecture. It was the counterpoint to all of this other work that was based on an earth augmentation problem. Then of course we got caught at the edge of the 90's economic crisis in Japan, which resulted in the cancelation of the project. I have to say that of all the projects to have never materialized in my career, this was the most painful.

GA: Yes. I remember how much the architecture community in Japan felt that it was a shame the project didn't move forward.

TM: Nice to hear. Anyway, some years passed, strategies evolved, but with this project we were able to get back to the roots or to reconnect to the lineage that started with the JPGA project.

GA: Even though this was an ongoing investigation of yours, the conditions had to be right to pursue further exploration?

TM: Yes. For instance, with Diamond Ranch High School, we had just begun working digitally. The first sketch was a computer drawing that was a shaping of the land—it is ultimately what we actually built. We left fragments of some of the earlier investigations that I'm discussing....pieces (the classroom elements) are visible as elements going down the field, the repetition of the bar elements, they all refer to Crawford, and more so to JPGA.

GA: So you have developed these ideas about relationship to the ground over many, many projects.

TM: Yes, definitely. But also, at this time the work was becoming more strategic and tactical on a series of levels. Just at the turn of the century we built the Hypo Bank (Hypo Alpe-Adria Center), at the edge of the city of Klagenfurt, Austria.

We approached this project with dual interests, one dealing with the augmented landscape, the other with an urban typology

GA: So your investigations of earth—building connections have involved a number of different scales.

TM: Yes. There's a second Hypo project in Udine (Hypo-Alpe Adria Bank) where the landscape folds through and connects again to the building. It's a little less aggressive than the first one at Klagenfurt. Then there were projects such as San Francisco (San Francisco Federal Building), Eugene (Wayne Lyman Morse United States Courthouse), fragments in Cincinnati (University of Cincinnati Campus Recreation Center), and NOAA (NOAA Satellite Operation Facility). Pieces of these ideas found their way into projects in different forms. With NOAA, their mission is to be keepers of the earth, so we decided that when they see their seven-acre site through their own satellites, they'll see

GA：大地に触れるということに当初から，ある種の本質的な結びつきがあったと？

TM：あのプロジェクトを見れば，私たちの葛藤を理解してもらえるのではないでしょうか。私たちは建築を地面に刻み，壁や，トーテムをつくろうとしました。多様でリズミカルな事象が敷地と交わるのです。一方で，クライアントは住宅にもっと普通のものを要望します。その結果，ハイブリッドなものとなる。振り返って見ると，これは来るべきものの暗示でした。大きな住宅ですが，その一方で，丘を下った斜面に埋め込まれているため，通りからは非常に控え目に見える。目に入るのは住宅ではなく，ランドスケープの要素として読解可能な弓なりの壁です。私たちが目指した概念は，ランドスケープ，グラウンドスケープ，そして建築のハイブリッドでした。

GA：グラウンドスケープという概念がその後，どのように発展していったのか教えて頂けますか？

TM：実はその直後に「JPGA」からオファーを頂き，仕事を引き受けました（「千葉ゴルフクラブハウス」）。「クロフォード邸」は明らかに，「JPGA」に大きく影響を与えています。「JPGA」ではさらに土地を掘り下げ，大地を切るといった空間操作をしています。

GA：60年代後半から70年代前半にかけてのアースワークの芸術家に繋がりますね。

TM：「JPGA」に関しては，私たちは意図して，ある要素を対位法として配置しました。つまり，自己完結した建築。建築学の伝統領域ですね。これは大地を拡張するという問題意識に基づいた，これまでの他の全ての作品とは対照的です。そして，例の90年代の日本の経済危機に捕まりました。私たちのプロジェクトもその結果，中止になってしまいました。多くのプロジェクトを，私はまだ何も実現していなかった。これが最も辛かったところです。

GA：プロジェクトが前に進まなかったことに日本の建築コミュニティが非常に失望していたのを覚えています。

TM：それを聞くと嬉しいですね。とにかく，何年かが過ぎ去るうちに方法論も進化しましたが，このプロジェクトのおかげで自分たちのルーツに立ち返り，あるいは「JPGA」に繋がる系譜を再発見できました。

GA：現在も進行中の研究であることと思いますが，さらに探究を進める上で，状況は正しい方向に進んでいるとお考えですか？

TM：ええ。例えば「ダイヤモンド・ランチ・ハイスクール」では，私たちはまだデジタル技術を導入したばかりでした。初めのスケッチはコンピュータドローイングで土地の形をいじるところから始めました――これが最後には形になる。これまでお話をしてきた初期の研究からいくつかを，私たちは断片的要素として配置しました。建築の部位（教室の構成要素）が場を構成する視覚的要素，反復する突起状要素となる。これらはすべて，「クロフォード邸」や，さらに「JPGA」を参照したものなのです。

GA：本当に多くのプロジェクトで場所性について考えられていますね。

TM：全くその通りです。同時にこの時期，作品もあらゆるレベルで，より戦略的，戦術的になってゆきました。ちょうど世紀の変わり目の頃に，私たちはオーストリアのクラーゲンフルトの郊外にハイポ銀行（「ハイポ・アルプ・アドリア・センター」）を建てました。

このプロジェクトに取り組む際，私たちには二つの関心がありました。一つはランドスケープを拡張すること，もう一つは都市のタイポロジーです。

GA：土地と建築との結びつきに関する研究は，多くの異なったスケールに及んでいるように見受けられます。

TM：ええ。ウディネにはハイポの次のプロジェクト，「ハイポ・アルプ・アドリア銀行」

△▽ *Diamond Ranch High School, Pomona, 1994-99*

Hypo Alpe-Adria Center, Klagenfurt, Austria, 1996-2002

Hypo Alpe-Adria Bank, Udine, Italy, 2003-06

Wayne Lyman Morse United States Courthouse, Eugene, 2001-06

empty land and one visible bar which houses their technology, the satellite dishes or "eyes and ears" of NOAA. Again, we're dealing with earth occupation.

GA: Yes, earth occupation.

TM: With the Giant Project in Shanghai, we are also working with a second idea that has another genealogy. Beginning let's say in a crude way from the Lawrence House, and in a more sophisticated way with the Bergren House (Venice III), and then definitely in the Crawford House, we were working with combinatory form, with an architecture that is made up of components and sub-systems. Not of objects, but rather, the relationship between objects. Everything is in some way an extension of that idea of relationships.

GA: So really in the Giant Campus in Shanghai you are bringing together two investigations which you have been pursuing for many years?

TM: Yes. What's happening recently—certainly by the time we get to Shanghai—starts as a series of interconnected elements that make up the total piece.

GA: This second investigation centers on interconnection, then.

TM: At that time, it was getting clearer that the work was responding urbanistically to the idiosyncratic nature of the site. Each facade was a reflection and an interpretation of a site condition, not an "object building" where the building is envisioned as a single object guided by its own set of rules, establishing a language and celebrating its autonomy, its singular authority.

GA: Can you explain a bit more about the connections of buildings and site?

TM: The trajectory of the work centered on the idea that the operational strategy would be a result of multiple generative forces. And this goes back to the idea that architecture is produced outside of the authority of a single person—an idea that is anathema to the current preoccupation with personality or with icon buildings. We operate at a system level that goes beyond our ability to deal with complicated problems. The first time we articulated this process was with ASE (ASE Design Center). We revealed the four elements in the built work, the pieces as they make a new potential for combinatory architecture. The interest was to produce highly differentiated spatial conditions that are responsive to the demands of their varied natures.

GA: How do you see building and site relating to biology?

TM: It parallels not the look of nature, not the look of biology, but the processes by which nature operates to produce infinite variety. We were creating an organization that was unquestionably coherent while simultaneously producing highly varied spatial types. It's looking to create that ineffable quality in architecture in which the architecture overpowers the day to day functional parameters of the work. This is finally what we admire....ideas made manifest.

So for instance, with Shanghai, we were able to articulate a series of elements to produce a more or less infinite variety of spaces whose qualities are able to respond to and initiate human behavior.

GA: It sounds wonderful! I'm really looking forward to experiencing such spaces.

TM: I'm interested in architecture as it initiates human behavior, as it opens up new possibilities and potentials. This is where the variety is infinite: if you cut sections through this building, no section is the same as another. It continually evolves into something else; it's emerging into something new.

GA: It sounds incredibly dynamic.

TM: Finally, this building is about those

があります。ここではランドスケープを折りたたみ，再度建築に結びつけています。これはクラーゲンフルトの最初のものよりは抑えた表現です。それから「サンフランシスコ連邦ビル」，「ウェイン・ライマン・モース合衆国裁判所」，「シンシナティ大学キャンパス・レクリエーション・センター」，「NOAA衛星センター」などのプロジェクトがあります。これまでの概念が断片として，さまざまな形でプロジェクトに反映されました。NOAAの使命は地球を監視することです。そこで私たちは，自分たちの衛星からこの7エーカーの敷地を見ると，何も無い土地に彼らのテクノロジーであるパラボラアンテナ，つまりNOAAの「目と耳」を収容した一本の棒のようなものが見えるようにしようと決めたのです。その土地に住むということ，ここでもそれに取り組みました。

GA：ええ，分かります。

TM：上海の「ジャイアント・キャンパス」では，私たちは別の系譜の，第二の概念にも取り組んでいます。初期の，例えば方法論も未成熟であった「ローレンス邸」や，より洗練された「ベルグレン邸」（「ヴェニスⅢ」），それから「クロフォード邸」ではかなりはっきりと，複合的形態，つまりコンポーネントやサブシステムによって構成された建築というものに取り組んできました。オブジェクトというよりは，オブジェクト同士の関係性。全てのものは，ある意味，そのような関係性という概念の延長なのです。

GA：上海の「ジャイアント・キャンパス」は，これまで何年もかけて進めてきた二つの研究を一つに結びつけているのですね？

TM：ええ，最近では，特に「上海」に取り組むようになってからは，相互に関係し合う一連の要素で全体のピースを完成させるようになりました。

GA：つまり，この第二の研究は，相互関係性に着目したものである，と。

TM：当時は，都市という観点から，建築とはそれぞれの敷地に固有の本質に応答するものだと，一層強く理解できるようになっていました。各々のファサードは敷地条件を反映し，解釈したものである。建築とは自己のルールで決定し，独自言語を確立し，自律性や唯一無二の権威を讃えるだけの，孤高の存在であると見なせるような，「オブジェ建築」ではないのです。

GA：建築と敷地の関係性について，もう少し詳しくお話頂けますか？

TM：建築を複合的に生成する力が戦略的手段になる。私たちの作品はそのような考え方を中心にして，軌跡を描いてきました。このことは，建築とは一人の人間の権限の外部で創造されるという概念に立ち戻ります――個性や建築の象徴性といった今の時代の先入観に対する呪詛と言っても良い。私たちは自己の能力を超えたシステムのレベルで複雑な問題に取り組むのです。このプロセスを明確に試みたのは，「ASEデザイン・センター」でした。私たちは四つの要素が既存空間を規定していることを明らかにしました。これらの断片が，建築的結合への新しい潜在的可能性を生み出す。多様な自然的要求に応答する高度に分化した空間条件を創造することに，関心があったのです。

GA：生物学という観点からは，建築や敷地をどのようにお考えですか？

TM：自然の見た目や生態系の見た目ではなく，自然が無限の多様性を創造するプロセスに類似性を見出すのです。私たちは高度に多様な空間的類型をつくり出す一方で，同時に完全に首尾一貫した組織体を生み出そうとしているところなのです。建築が日々の生活の機能的パラメータを圧倒する。そのような，たぐい稀な優越性を建築に内在させることを目指しているのです。これこそが，私たちにとって最終的に賞讃するもの……つまり概念の顕在化なのです。

例えば，「上海」では，空間に無限の多様性をもたらすために，本質的に人の動きに反応し，また，人の動きに変化をもたらしてくれる一連の空間的要素をうまく表現す

United States Federal Building, San Francisco, 2000-07

University of Cincinnati Campus Recreation Center, Cincinnati, 1999-2006

NOAA Satellite Operaiton Facility, Maryland, 2001-05

Venice III, Venice, 1982-86

Lawrence Residence, Hermosa Beach, 1984

Sixth Street Residence, Santa Moinca, 1987-92

two forces, one of which is landscape. I think it's the closest I've come to developing a relatively uncompromised fusion between landscape and architecture. The second force is the organizational strategy that has to do with combinatory form in a building that's generated from an external logic.

GA: So you have brought together your investigations of ground and investigations of interconnectedness within a highly complex system.

TM: I'm interested in the space between willfulness and chance. Willfulness, consciousness—that's where architects have always begun; you draw the line, there is an authority to the line—and now this is overlaid with chance behavior, which emanates from the system. It's something that's spontaneous and serendipitous and that's outside of my control. And it produces the space between that oscillates back and forth between our interventions. This same conversation connects to architecture as a collective act.

As soon as I'm working with my team, we are working together and we can operate because we have a system, a set of rules in which we are in agreement. It is a set of flexible rules, not mechanical, that have a large amount of interpretive potential.

Finally, this notion of combinatory form and a set of prescribed rules is, I think, linked to the beauty of the logic that guides us. Behind the things we admire is a complicated structure that behaves consistently.

GA: Yes, the beauty of systems in nature.

TM: Exactly. The operational method involves changes in the system itself. It's the evolution of the method and the first principles that are connected to that method and/or system, which really is the source of a new direction in architecture.

GA: You're talking about systems research.

TM: Yes. As can be observed in the sciences, it is the research that uncovers the underlying structures or patterns of cellular behavior which, when combined with the intuition of skilled practitioners, eventually leads to resolution or cure in the case of medicine. Does that make sense?

GA: Yes, there are a multitude of systems and only through research can we discover and then work within a particular system.

TM: I'm comfortable with the authority of a line but finally I understand its limits....I'm much more comfortable with broader systems. The system approach leads to some idiosyncratic results. There are some architectural moments in the Giant Campus that happened accidentally. I had nothing to do with them and I like them very much and would not be interested in changing them. They were a series of elements coinciding.... that occurred because we were working within a system. The system has a much broader potential of inventing immensely complicated, even serendipitous interactions that are beyond our ability to foresee or impact.

GA: So, in a way, the system provides access to an expanded vision?

TM: Yes, it allows for us to operate somewhere in the middle ground between willfulness and chance. That is the space I'm interested in. But, with a lot of the work this is now just an influence of something much more disciplined by the reality of the functionalities and constraints of architecture.

GA: So pragmatics often hinders your investigations into these issues?

TM: There's another area of the work that changes in terms of how closely the work follows our ideas and how much of it is absorbing other demands. When I'm showing the work tonight in the lecture

ることができました。

GA：素晴らしいですね。実際に体験するのが楽しみです。

TM：私には人の動きに変化をもたらす建築に関心があるのです。新しい潜在的な可能性を開いてくれますから。それゆえ，多様性は無限に広がるのです。この建築の断面は，一つとして同じ断面は無い。連続して，何か別のものへと進化するのです。そこから，何か新しいものが現れるのです。

GA：非常にダイナミックですね。

TM：最終的に，この建物には二つの力が関わっています。比較的妥協することなくランドスケープと建築の融合を発展させることに，今回最も近づくことができたと思っています。外部の論理から生み出された建築の中にある複合的形態に関係する組織的戦略が，二つ目の力です。

GA：そこであなたは地面に関する研究と，相互関係性に関する研究とを，非常に複雑なシステムに統合された。

TM：計画性と偶発性のあいだの空間に関心があるのです。計画性と偶発性――建築家はいつもそこに着目します。そこで線を引く。そしてその線には確信的な何かがあるのです。そして，今度はシステムから生じる思いがけない振る舞いを重ね合わせてみる。これは何か，自分ではコントロールすることのできない，自然発生的で，思いがけないものなのです。そしてこのことが，私たちによる干渉のあいだで揺れ動く，中間的空間を生み出すのです。同じ論理が，集合的行為としての建築に結びつく。

チームで仕事をすると，すぐに一緒に共同作業ができるようになる。というのも私たちにはシステムが，すなわち自分たちで合意したルールがあるからです。これは機械的なものではない。順応的な解釈について膨大な潜在可能性のあるルールなのです。

複合的形態や規定されたルールといったこれらの概念は，最終的には私たちを導く美へと繋がってゆくと，私は考えています。私たちが賞賛する物事の背後には，一致した行動を示す複雑な構造があるのです。

GA：自然に内在するシステムとしての美しさですね。

TM：その通りです。システム自体の変更も，戦略的方法論の一つになります。方法論が進化し，第一原則が，方法論とシステムの両方またはいずれか一方と結びつき，現実には新しい建築の方向性の源となるのです。

GA：システム論ですね。

TM：ええ。科学の分野ではよく見られることです。研究こそが細胞の働きに内在する構造やパターンを明らかにする。そして医学の場合であれば，腕のよい臨床医の直感もあって，そのような研究が，最後には解決策や治療へと結びつくのです。お分かりいただけますか？

GA：ええ，非常に多くのシステムがある。そして研究を通してのみ，特定のシステムを発見し，その中に入ることができる。

TM：線形的な権力というものには満足していても，最終的に，そこには限界がある――私にとっては，より広汎なシステムの方がよい。システム的なアプローチは，それ特有の結果を導きます。「ジャイアント・キャンパス」では，いくつか建築的に見て重要な転機が偶然訪れました。それは私とは関係なく起こったことでしたが，それが良かったので，逆らって変える気にはならなかったのです。一連の要素がそこにぴったりと一致する……システムの中で仕事をしていると，そのようなことが起こる。システムには，先を見通して影響を与えるといった私たちの能力を越えたところに，非常に複雑な，幸運でさえある相互作用を発見するための，より広汎な潜在的可能性があるのです。

GA：つまりある意味，システムは拡張的ヴィジョンへのアクセスをもたらしてくれるということですか？

ASE Design Center, Taipei, 1996-97

△▽ *41, Cooper Square, New York, 2004-09*

I'm going to talk about some of the work that is driven by its own constraints. That's what most architecture is. Cooper Union (41, Cooper Square), for instance, was hugely constraint driven.

GA: What kind of constraints did you face with Cooper Union?

TM: The entire program was predetermined. Done. And yet the requirements of the program barely fit the site given the constraints of the building rules and regulations in New York City. So I take what's left over. I develop the core, I shape the exterior of the building. Of course, most architecture comes out of dealing with constraints. There are these two territories that become clearer to me as I get older. I can separate the work that's constraint driven. And there's nothing wrong with it, in fact maybe some of our most beautiful work is about constraints. On the other hand, there is work that is much more open for invention, where the work is driven by a conceptual force. So somehow our challenges vacillate between trying to find architecture amidst highly constraint-driven projects; and then having more freedom, such as what we had in Shanghai, to invent things informed by our own conceptual language and system strategies. And ultimately these open-ended projects lead to an interest in developing larger-scale work at the urban scale....the strategies we're working with are applicable to the development of cities, something we are very interested in pursuing.

GA: You seem really energized by the project and by its potential to develop into larger urban work.

TM: It seems like an amazing time right now to research the nature of the types of strategies that will allow us to deal with the problem of urban planning. What energizes me is both the scale and the infinite complexity. And not just on a formal level, I'm talking about the political, cultural, and social realms. It's finally about architecture's potential to provide enhancement to the user, to the human character who will occupy it. And more than the buildings that will occupy the area, it is the connective tissue that is critical, that works to create opportunities for interaction and connection, not isolation.

GA: Interaction and connection make up much of urban life.

TM: If you look at what's going on in China, most of the new development is comprised of a series of objects; it's the worst of modern planning. There seems to be a huge amount of criticism for this, but just about no research. What we need in the practice of architecture is to advance the strategies and methods by which we investigate complex, integrative urban problems so that we can produce cities that both mirror and add to the richness and complexity of the human condition.

Interview by Yoshio Futagawa
October, 22nd, 2010, at GA gallery, Tokyo

TM：ええ。計画性と偶発性の中間の地平のどこかで，私たちが関わるのを可能にしてくれるのです。そのような空間に，私は関心があります。しかしながらシステムとは，現実には建築の機能性や制約といった規律が空間に及ぼす影響力のことでしかないことが多いのです。

GA：実用主義がしばしば，これらの問題に対するあなたの研究の妨げになると？

TM：その作品がいかに自分の思想に肉薄しているか，あるいはいかに他の要求を取り入れたものであるか，建築には異なった側面があるのです。今晩，レクチャーをする予定なのですが，自己の制約の中からいかに作品が生まれるのか，作品を見ながら話したいと思っています。建築とは，多くの場合そのようなものです。例えばクーパー・ユニオン（「41，クーパー・スクエア」）ですが，これは厳しい制約の中から生まれました。

GA：「クーパー・ユニオン」に関してはどのような制約に直面していたのですか？

TM：プログラムは全て，あらかじめ決まっていました。それで全てでした。しかも要求されたプログラムでは，ニューヨーク市の建築規制と法規による制約の下でその敷地に建てることは，ほぼ不可能でした。そこで残されたものに着目し，コアを発展させて，建築の外形を決める。もちろん，建築とは制約から生み出されることがほとんどです。私も歳を取るに従って，建築には二つの領域があるということが分かってきました。制約で決まる作品が，見て分かるようになったのです。これはなかなか悪いことではない。実際，最も優れた私たちの作品は制約に深く関わっています。その一方で，抽象的な力学によって決まる時のように，発見するということに対してより開かれた作品がある。厳しい制約に支配されたプロジェクトの直中に建築を見出すことができるように試みることと，その上で，「上海」のように，私たち自身の抽象言語や，システム戦略を特徴としたものを発明し，より一層の自由を手中にすること。私たちの挑戦はともかくも，これらの間を揺れ動いているのです。そして最終的には，これらの終わることのないプロジェクトが，都市計画のように大規模な仕事への取り組みに対する関心に至るのです——私たちが取り組んでいる方法論は，私たちにとって非常に大きな関心である，都市開発に応用することが可能なのです。

GA：プロジェクトや，より大規模な都市開発の持つ潜在的可能性についてのお話は実に力強いですね。

TM：方策を類型化し，その本質を研究することで，都市計画の問題に取り組むことができる。そのように時間を割けるというのは素晴らしいことです。私に力を与えてくれるのは，規模と，無限に広がる複雑性です。それから私は単なる形態論のレベルではなく，政治的，文化的，社会的領域について論じてきました。最終的に，利用者や住む人の人間性に豊かさを与えてくれるのは，建築の潜在的可能性なのです。そしてその場所に建つ建築以上に，連続した組織体が重要なのであり，それこそが孤立ではなく相互交流や人との繋がりの可能性を生み出すのです。

GA：都市生活の大半は相互作用と連続性によるものですね。

TM：中国で今起こっていることに目を向けると，新しい開発計画の多くはオブジェクトで構成されただけの最悪の都市計画です。このことについては膨大な数の批評がありますが，研究は十分ではない。
　私たちにとって建築を実践する上で必要なのは，複雑で総合的な都市問題を研究するための方策や方法論を促進することなのです。そうすることで，私たちは人間の条件の豊かさや複雑性を反映し，増幅させる都市をつくり出すことができるのです。

2010年10月22日，GAギャラリーにて
聞き手：二川由夫

Photos: GA photographers except as noted
** Courtesy of Morphosis Architects*

Thom Mayne at Morphosis Exhibition, Pompidou Centre, Paris, 2006

University of Chicago Center for Creative and Performing Arts

2006 Chicago, Illinois, U.S.A.

Second floor

Fifth floor

First floor

Fourth floor

Cross section

Longitudinal section

1 LOBBY	15 SCULPTURE STUDIO	29 SEMINAR
2 PUBLIC EXHIBITION	16 COVERED SCULPTURE COURTYARD	30 WORKING EXHIBITION
3 STUDENT LOUNGE	17 OFFICE	31 TEMPORARY EXHIBITION
4 CAFE	18 DIRECTOR OFFICE	32 CONFERENCE
5 OUTDOOR TERRACE	19 MANAGEMENT OFFICE	33 PAINTING & DRAWING STUDIO
6 VISUAL ARTS CONSTRUCTION	20 BLACK BOX THEATER	34 LECTURE
7 TOOLS	21 ART DEPARTMENT RECEPTION	35 THEATER REHEARSAL
8 MATERIALS STORAGE	22 LOUNGE & CONFERENCE	36 CLASSROOM
9 PLASTIC WORKSHOP	23 INSTRUMENT STORAGE	37 AUDITORIUM
10 METAL WORKSHOP	24 SMALL ENSEMBLE	38 TRAP AREA
11 SCENERY PAINT AREA	25 LARGE ENSEMBLE	39 FILM VAULT
12 PROPS	26 PRACTICE ROOM	40 OUTODOOR WORKSPACE
13 SCENERY & PROPS	27 PERFORMANCE TEACHING STUDIO	
14 STAGE	28 INDIVIDUAL STUDIOS	

Site plan

The Center for Creative and Performing Arts (CCPA) coalesces the University of Chicago's arts departments in a transformative facility that creates unprecedented opportunities for interdisciplinary exchange. This new world-class center will be an iconic symbol of the University's commitment to academic excellence, innovation, and curricular integration. Based on our team's rigorous analysis and synthesis of the University's goals, we have developed an efficient, integrated solution, organized around the following key principles:

Advancing an Architectural Legacy
The new CCPA will be a powerful symbol of commitment to the South Campus and its surrounding community, and is poised to become a catalyst for the area's future development. The new building will draw students to this currently underutilized area of campus. Its bold, vertical forms optimistically proclaim the CCPA as an iconic identifier for the arts, a new gateway to the campus, and a landmark that brings civic pride to the neighborhood.

Incubating Creativity
The building is conceived as an incubator of creativity. Our vertical scheme deliberately creates a denser, more efficient building, with intensified public spaces. Its spatial and symbolic heart is a central atrium that rises to the full height of the building. This vertical piazza—a contextual re-interpretation of the University's indigenous quadrangle—functions as a connective volume, opening view corridors and creating physical links between departments. All of the users circulate through this central core, creating opportunities for synergetic encounters, interdisciplinary collaboration and new ideas. The proposed, more efficient scheme meets the University's programmatic goals while reducing the total gross area of the project (circulation spaces are reduced by approximately 22,000 sq.ft.) resulting in a building concept with a significantly reduced budget. If the University wishes to redistribute this 22,000 sq.ft. for additional informal meeting areas, our scheme can accommodate this request without jeopardizing the project's design integrity.

Strategic Campus Planning
To date, the University's land assets have accommodated its expansion goals; however, based on the University's projected growth, it will be necessary to acquire new property within the next 10-15 years. In anticipation of the University's imminent need for more land, our scheme strategically occupies only one third of the site, leaving the remaining two thirds open for future development. This site strategy affords a major opportunity for campus planning, and establishes the parameters for a dense, vertical landmark building that defines the edge of campus.

Framing the Historical Context
Deliberately scaled to act as a beacon, the CCPA's distinctive cantilever is visible from the Midway and the surrounding community. This cantilevered form dramatically frames the historic Lorado Taft Midway Studios. The cantilever recedes at the southeast corner to respect the historic building and allow light to pass through; a large aperture is optimally shaped to allow natural light to stream through the new 5th-storey art studios to the historic building's studios. This projecting volume affords sweeping views across the Midway, and shelters the exterior courtyard below. Never physically attached to the historical structure, the new building maintains open views of the Lorado Taft Midway Studios from all sides, respecting the legacy of architectural innovation and the heritage that defines the University and the greater Chicago context.

Integrating Sustainable Design
Building upon the University's and the city of Chicago's progressive stewardship of the environment, our scheme for the CCPA incorporates a range of low energy, high environmental quality design initiatives that contribute to the conservation of the environment through the intelligent utilization of resources. Ours is a holistic design approach that will strive to attain the highest possible level of sustainability.

シカゴ大学創造・舞台芸術センター（CCPA）は，これまでに前例のない各学部間での学際的な交流の機会を創造し，変化をもたらす力を持った施設によって，各美術学部を融合し，連合していく計画である。この世界的レベルをもって設計された施設は，シカゴ大学の卓越した学問追求の姿勢や革新性，そして教科課程の集大成に向けた真摯な取り組みを示すアイコンとなるだろう。設計チームによる大学側の要求条件の綿密な分析と統合化により，以下のように系統立って提示された主要方針を中心に，我々は能率的で組織化された解法を展開させている。

〈建築的遺産の改善と向上〉
新しいCCPAは，大学の南地区キャンパスとその周辺コミュニティに真摯に向き合う力強いシンボルとして，この地域の将来的な発展の刺激となる準備が整っている。新しい建物は，現在有効利用されていない大学のこのエリアに学生を引き寄せる要素となるだろう。力強い垂直性を持ったその形状は，芸術分野全体を結びつけ一体感を呼び起こすアイコニックな姿を示すことで，CCPAがこの大学キャンパスにおける新たな通路となり，さらに周辺コミュニティが市民としての誇りを持てるようなランドマークとなることを，希望を持って宣言する。

〈創造性の培養装置〉
この建物は「創造性の培養装置」として表現されている。我々が提案する垂直性を持つこの建築案は，強調された公共空間のコンセプトと共に，意図的に高密度でより効率の良い建物を生み出している。建物の最高点まで突き抜ける中央アトリウムは大きな空間的広がりを持ち，象徴的にこの建物の中心を成すものとなっている。この垂直広場——方形の中庭を建物が取り囲んでいた大学の当初の姿を再解釈したコンセプト——は接続空間として機能し，眺望を切り開く通路や各学部の間を結ぶ物理的な接続スペースをつくり出している。全ての利用者がこの中央コアを通って移動することで，偶然の出会いや学部の枠を越えた共同作業，新しい考え方など，相互作用のある機会を生み出す。大学の求めるプログラムを満たしつつ，プロジェクトの延床面積を削減したより効率的な案が提案され，（動線空間において約22,000平方フィートが削減された）結果としてこの案は大幅に予算を削減するものとなった。もし大学側が削減されたこの22,000平方フィートを再分配して一連の社交スペースを追加したいと望めば，我々の案は設計における一貫性や調和を崩すことなくこの要求に適応させることができる。

〈戦略的なキャンパス計画〉
これまで，大学の所有する土地資産は拡張計画の目標を受け入れるのに充分であった。しかし，大学側が想定している成長率によれば，今後10年から15年の間に新しい敷地を取得する必要が出てくる。こうした大学側の切迫した新規敷地の必要性を見越して，我々の提案では敷地の三分の一のみを効果的に用い，残りの三分の二の敷地は将来の拡張計画のために残している。この敷地戦略は将来のキャンパス計画において非常に大きな発展見込みをもたらすとともに，垂直性を持った高密度のランドマーク建築を確立してキャンパスの周縁部を規定していくという我々の建築提案における重要なパラメーターともなっている。

〈歴史的な文脈の囲い込み〉
灯台のような，ある種の標識としての役割を果すべく意図的に設計されたCCPAの特徴的なキャンティレバーによる片持ち構造は，ミッドウェイ公園や周辺のコミュニティからも見える。このキャンティレバーによる形状は，歴史的価値を持つロラード・タフトのミッドウェイ・スタジオの建物を劇的な形で取り囲んでいる。キャンティレバーはこの歴史的な建物へ敬意を示す形でキャンパス南東コーナーでは後方に遠ざけられており，タフトのスタジオ建築へ自然光が射すように考慮されている。最適化された形に大きな開口部が設けられ，この新しい5階建ての美術スタジオを通り抜けてタフトの歴史的なスタジオ建築に自然光が差し込むようになっている。

〈統合された持続可能性に向けた設計〉
シカゴ大学とシカゴ市による環境問題に対する進歩的な管理者の立場に則り，我々のCCPA案は，エネルギーの知的利用を通じて環境を保全していくことに寄与する，率先した低エネルギー消費と高度な環境対応を統合した設計となっている。この案は想定しうる最高度の環境保全性と持続可能性を達成する努力とも言うべき，我々の包括的な設計への取り組みである。

View from west

CIRCULATION

INTERDISCIPLINARY COURTYARD

THEATER SUPPORT

STRUCTURE

EXISTING AND PHASE 1 PHASE 2

INTERDISCIPLINARY STUDY

THEATER PUBLIC

VERTICAL QUAD

STUDENT FACULTY STUDY

MUSIC

FILM

PERFORMANCE

VISUAL ARTS

Program

48

View from east

Structural diagram — STRUCTURAL MEMBERS

Structural forces diagram — TENSION / COMPRESSION

Section: mechanical system

- COOL ROOF
- RADIANT CEILINGS
- RADIANT FLOOR IN LOBBY
- AIR EXHAUSTED FROM ATRIUM
- VARIABLE AIR VOLUME
- DISPLACEMENT VENTILATION
- VENTILATION FROM BELOW SEATS

Atrium

Exploded element of Atrium

Atrium

New Orleans National Jazz Center

2006–08 New Orleans, Louisiana, U.S.A.

Street view on east

View of foyer

Diagram: program analysis

Site plan

An Optimistic Vision to Reactivate the City Core

In 2005 Hurricane Katrina covered 80 percent of the city with water and damaged or destroyed 62 percent of its housing stock. Despite the city's enormous loss, its love of music and its musical heritage remains unwavering. Everyone knows the city will rebuild, but few know how. As jazz is the cultural backbone of the city, can it also act as generative material to renew, reactivate, and rebuild? The National Jazz Center offers such a catalyst, an optimistic vision to reactivate the city core and, in so doing, infuse the community with a sense of civic pride.

Within walking distance of cultural venues, historic jazz sites, and parks, as well as public transit and two major interstate highways, the National Jazz Center anchors a round-the-clock cultural district and civic center, and provides an optimistic vision for New Orleans's rejuvenation. The National Jazz Center's performance and exhibition space hosts the New Orleans Jazz Orchestra, the Jazz Heritage Festival, and other concert, business, and cultural events.

The raised volumes of the main jazz performance hall and the 350-seat black-box theater float above an open public plinth, elevated 10 feet above street level to safeguard from flooding. Designed to create an intimacy fitting the heritage of jazz performance, the 1,000-seat theater's spirit is more akin to jazz joint than formal performance hall. Seating in the round and tiered balconies pull the audience in toward the performance, with no seat more than 55 feet from the stage—close enough to see the saxophonist's expression or the bassist's hands.

The public character of the Jazz Center's facade, outdoor lobby area, and colonnade along Poydras Street activates the surrounding urban context. A grand stair leads from Poydras Street to a large entry lobby, which flows into a cafe and exhibition area located on this public level. The lobby's soaring ceiling follows the incline of the tiered theater seating above, sloping up from the more intimate 9-foot-high exhibition area, to meet the ridge of the Poydras Street facade. This sloped ceiling, visible from outside, provides opportunities for media projections. The Jazz Center's grand entry stair, the outdoor lobby area that anchors the corner and the generous colonnade along Poydras will help to create a vibrant public space and an optimistic public presence.

Cross sections

Longitudinal section

0 10 25 50 ft

1 EXTERIOR PERFORMANCE
2 CAFE
3 LOBBY
4 KITCHEN
5 GIFT STORE
6 EXHIBITION
7 FOYER
8 LOADING
9 MECHANICAL
10 VEHICULAR DROP-OFF
11 PARKING
12 CONNECTIVE BRIDGE
13 PERFORMANCE HALL
14 ORCHESTRA PIT
15 STAGING AREA
16 STUDIO THEATER
17 AMPLIFIER ROOM
18 STORAGE
19 EQUIPMENT STORAGE
20 GREEN ROOM
21 DRESSING & WARM UP
22 PROJECTION
23 TECHNICAL OFFICE
24 RECORDING
25 LIGHTING
26 OFFICE
27 LOCKERS
28 PRACTICE
29 REHEARSAL
30 TECHNICAL BOOTH
31 STUDIO THEATER GALLERY

East elevation

〈都市中心部を復活させる楽観主義的ヴィジョン〉

2005年のハリケーン・カトリーナでは市街地の80%が浸水し，住戸数の62%は損傷を受けるか，倒壊している。だが，市街地の膨大な損失にもかかわらず，音楽への愛情と，音楽の伝統は揺るがないものであり続けた。この都市が再建されるのは自明である。だが，どのようにすればよいのか。ジャズはこの都市の文化的根幹である。この素材から都市を再生し，復活，再建することができるだろうか？ 国立ジャズ・センターは触媒として都市中心部を活性化し，またそうすることによって，コミュニティを市民的尊厳で満たすため，楽観主義的ヴィジョンを提供する。

公共交通機関や2本の主要州間高速道路のほか，文化的中心地，伝統あるジャズ・スポット，公園などから歩けるところに，国立ジャズ・センターは文化エリアと市民センターをしっかりと根付かせる。ニューオーリンズの再活性化のために楽観主義的ヴィジョンを提供するのだ。国立ジャズ・センターのパフォーマンス・展示空間では，ニューオーリンズ・ジャズ・オーケストラ，ジャズ・ヘリテージ・フェスティバル，また，他のコンサートやビジネス・文化イベントが主催される。

メイン・コンサートホールと350席のブラックボックス・シアターからなる背の高いヴォリュームは，洪水から身を守るため道路面から10フィート（約3m）高く，一般に開放された基壇部分の上空に浮遊する。1,000席を収容できるこのシアターに宿る精神は，正統的コンサートホールというよりは，ジョイントライブのものと同質である。ここはジャズ演奏の伝統を彷彿とさせるように設計されている。ステージからの距離を全て55フィート（約16.7m）に抑えた円形状の階段バルコニー型の客席は，聴衆を演奏へと引き込ませる——サクソフォン奏者の表情やベーシストの手の動きを楽しむには十分である。

ジャズ・センターのファサードや屋外ロビーエリア，ポイドラス通りに沿ったコロネードといった公共的性格が，周辺の都市的文脈に彩りを与えている。ポイドラス通りからの大階段は大エントランス・ロビーへと続き，パブリックフロアのカフェと展示エリアへ空間が流れ込む。ロビーの抜けるように高い天井は，上階のシアターの階段状の客席の傾斜に沿って，9フィート（約2.7m）の高さの落ち着きある展示エリアを駆け昇る。そして最後にはポイドラス通りのファサードの頂部と交わる。このように外からも視認可能な傾斜した天井面には，映像を投影することができる。ジャズ・センターの大エントランス階段，すなわち敷地の角とポイドラス通り沿いの力強いコロネードとを結びつける屋外ロビーエリアは，活気あるパブリックスペースと楽観主義的な公共性の出現を促すだろう。

Fifth floor

Fourth floor

North elevation

Second floor

Sectional model of performance hall

Foyer

Bridge at foyer

Staircase at foyer

Phare Tower

2006-15 La Défense, France

Level 01

Level 11

Ground level

Level 09

1 LOBBY
2 OFFICE
3 PLAZA
4 PAVILION
5 ESCALATORS TO MAIN TOWER ENTRY
6 RETAIL
7 AUDITORIUM
8 CAFE
9 ROOF GARDEN
10 KITCHEN
11 RESTAURANT
12 WIND TURBINES
13 GRAND HALL

Synthesizing Idiosyncrasies to Mend a Site
Drawing on the power of parametric scripting, the design of the Phare Tower gathers disparate programmatic, physical, and infrastructural elements from the requirements of the building and its surrounding context, and synthesizes these into a form that seamlessly integrates the building into the idiosyncrasies of its site while expressing multiple flows of movement. In the spirit of the Paris Exposition competition proposals, the tower embodies state-of-the-art technological advances to become a cultural landmark.

The complex structure and skin adapt to the tower's nonstandard form while simultaneously responding to a range of complex, and often competing, physical and environmental considerations. Technologies integrated into the Phare Tower capture the wind for the production of energy and selectively minimize solar gain while maximizing glare-free daylight. Its high-performance skin transforms with changes in light, becoming opaque, translucent, or transparent from different angles and vantage points.

Between 1958 and 1989, high-rise buildings (banned in the historic center of Paris) were constructed just outside the city boundary, forming the business district of La Défense two miles west of Paris. The Phare Tower (phare being French for beacon or lighthouse) marks the first stage of a major redevelopment of the district. La Défense is currently a zone of discrete, isolated buildings amid blank plazas—essentially a nonsite.

The tower emerges from its irregular site, defined by a neighboring motorway and a rail link, and bisected by an existing pedestrian walkway. It is located between the 1989 Grande Arche de la Défense and the 1958 CNIT building, the former exhibition hall of the National Inter-University Consortium for Telecommunications, with an architecturally significant glass facade, designed by Jean Prouvé. These disparate elements, crowded together and seemingly unrelated, provide an opportunity to mend the site. The site strategy thus synthesizes the programmatic, physical, and infrastructural complexities to connect the surrounding urban space and create a coherent sense of place where none previously existed.

At the levels of urbanism and circulation, the scheme complements existing plans to transform the CNIT into a center for commerce and recreation. Circulation is directed from the existing transit hub below grade, through the renovated CNIT facilities, and into the tower's public spaces via a pavilion. The pavilion connects to the Place Carpeaux, and transitions from horizontal to vertical, becoming an integral element in the tower's form. Glazed exterior escalators

Level 37

Roof

Level 27

Level 67

soar 35 meters from the pavilion to the tower's ninth-floor lobby, transporting approximately eight thousand pedestrians each day. As the visitor rides up the escalators to the Grand Hall, the fully glazed envelope reveals views of the traffic passing underneath, as well as of Parisian monuments in the distance.

Rather than an isolated and autonomous tower, the building is a hybrid structure. The 300-meter tower straddles the site to meet the ground as a tripod. It comprises one splayed structural leg, two occupiable legs (the Trapezium, to the west, and the East Building), as well as a pavilion that engages the surrounding context and transforms the public space of the plaza. The two occupiable legs frame a 24-meter-wide by-28-meter-tall void in the tower's base, creating a monumental urban gateway, which maintains view corridors toward the CNIT and toward Courbevoie and allows pedestrian traffic to flow directly underneath the building.

As it rises from its tripod base, the tower's asymmetric profile swells slightly to accommodate the soaring Grand Hall, then becomes more slender in response to wind load, and finally tapers off to a thicket of wind turbines, antennas and hair-like structures on the roof. The tower appears to shift continually, distinct from different vantage points—not a single image but a dynamic structure that responds to its site, environment, and performance requirements. At its base, the building's skin opens, exposing a 250-foot-high Grand Hall. The Grand Hall becomes the center for all vertical transportation. From the Hall's security checkpoint, people transition to double-deck banks of express elevators serving the office tower. On the 66th floor, a sky restaurant and a panoramic terrace, offering spectacular 270-degree views, are open to the public. Overall, the project comprises 146,988 m² or 1,582,166 sq.ft. of net surface area and 164,185 m² or 1,767,273 sq.ft. of gross surface area.

Technologies integrated into the Phare Tower harness the wind for the production of energy and selectively minimize solar gain while maximizing glare-free daylight. The tower is crowned with a cluster of antennas and a wind farm of turbines that harvest energy—a metaphorical garden in the sky. Both the form and the orientation of the building respond to the path of the sun. The planar, clear-glazed north facade maximizes interior exposure to year-round natural daylight. A curvilinear second skin of diagonal stainless steel mesh panels wraps the tower's continuous south, east, and west glazed facades to minimize heat gain and glare and maximize energy efficiency.

Diagram: procession, grand hall

Diagram: site connectivity

Diagram: elevator shafts

Site plan

SOLAR SHADING SKIN OPTIMIZATION SOLAR SHADING SKIN JOINT ANGLES SOLAR SHADING SKIN UNITIZATION GLAZING PANEL UNITIZATION

Diagram: solar shading skin

2007 March 2007 May 2007 June 2007 June 2007 July 2008 March 2008 May

Evolution of structure

0 25 50 ft

1 PAVILION
2 OFFICE
3 PLAZA
4 GRAND HALL
5 VIP DROP-OFF

Section

63

〈敷地を改善する固有な諸特性の統合化〉
ファール・タワーの設計は，パラメトリック・スクリプティング（一連の作業手順に変数を用いる手法）の力を応用することで，この建物とその周辺の文脈に対し要求される，本質的に異なったプログラム，物理特性，インフラ基盤といった諸処の要素を総合的に捉え，このタワーを敷地特性に継ぎ目なく共存させながら，敷地内の複数の動きの流れを表現する形体へとこれらの要素を合成し，統合した。パリ万博設計競技案の精神に則り，このタワーは文化的ランドマークとなるよう，最新鋭の技術的進化を体現するものとなっている。

この複合構造と建物の表皮は，このタワーの標準的とは言えない形体に適合しつつ，複雑で，時に競合する物理的要素や環境への配慮にも応えるものとなっている。ファール・タワーに統合された技術は，風力を発電に用いながら，太陽光による屋内の熱取得を選択的に最小化し，かつ眩しさを抑えた自然光の室内採光を最大化する。この高機能な建物の表皮は，太陽光の状況に応じて変化し，異なる角度と見る場所によっては不透明になったり，半透明になったり，時には透明にもなる建築要素となる。

1958年から1989年にかけて，パリ市の境界のすぐ外側に一連の高層建物（パリ歴史中心区では禁止されていた）が建設され，パリの西側2マイルの場所にラ・デファンスビジネス地区を形成した。ファール・タワー（"ファール"はフランス語で航空標識や灯台を意味する）はこの地区における大規模再開発計画の最初の段階をこの地に記すものとなる。ラ・デファンスは現在，不連続に離散した建物が空白の広場の只中にあるような区画であり，基本的に建物のための敷地とは呼べない状況にある。

このタワーは，車道と鉄道連絡路が隣接し，既存の歩行者通路で二分された統一性のない土地から立ち上がることになる。敷地は1989年に落成されたグラン・ダルシュ・デ・ラ・デファンスの建物と，ジャン・プルーヴェの外観デザインにより1958年に完成し，建築的には際立ったガラスファサードで知られ，以前はコンベンションセンターとして使われていたCNIT国立産業技術センタービルの間に位置している。一緒にこの地に押し込まれ，一見したところ関連がないように思われるこれらの異質な既存要素が，この敷地を改善していく機会を与えるものになると考えた。よって今回のプロジェクトにおける敷地計画では，周辺の都市的空間と接続され，一貫性をもって密接に結びついた感覚を得られるような，これまでこの地区に存在していなかった場所を創造するために，既存のプログラムや物理的要素，さらにインフラ基盤がもたらしている複雑さを合成し，統合している。

都市性や動線において，我々の提案は既存の状況を補完し，CNITビルを商業施設と娯楽施設の中心として変容させる。動線は地下に位置する鉄道連絡ハブから直接導かれて改装されたCNITビルの施設群を通り，タワーから張り出したパヴィリオンを抜けてタワーの公共スペースに接続される。このパヴィリオンは，カルポー広場に接続し，水平的な状況から垂直的な状況へと移行して，タワー状に一体化してゆく。ガラスで覆われた外部エスカレータはこのパヴィリオンから35mの高さへと上昇し，一日におよそ8,000人の歩行者をタワー9階にあるロビーへと運ぶ。エスカレータに乗って訪問者がグラン・ホールへと昇る際には，ガラスによって覆われたエスカレータから下を横切っていく車の流れや，パリ市民のモニュメントの数々を遠くに見渡すことができる。

孤立して自律的なタワーというよりも，この建物は異なった要素が結合した構造となっている。高さ300mのタワーは地上面では三脚状になって接地し，敷地をまたいで立っている。このうち一つは斜めの構造脚で，他の二つは内部空間のある脚（建物西と東にある台形のもの）であり，さらに周辺の文脈へと繋がって公共広場を変容させていくパヴィリオンから構成されている。占有可能な二つの脚部はタワーの基部において24m幅，28m高の空隙を枠どっており，記念碑的な都市通路として，CNITビルやクールブヴォア地区への眺望を保全しながら，さらに歩行者が直接建物の下部を通り抜けることのできる空間を創り出している。

タワーは三脚状の基部から立ち上がりながら，高くそびえるグラン・ホールを内包するために非対称的な側面像をもってわずかに膨張し，その後風荷重を考慮してより細長く変形しながら，最終的には雑木林の茂みのような風力タービンやアンテナ，髪の毛のように細い構造体へと先細りに変容していく。タワーは様々な眺望ポイントから独特な姿を見せる——それは，ある決まった一つのイメージではなく，ダイナミックな構造体としてこの敷地や環境，そして性能要求といった条件に応えるものとなっている。タワー基部では，建物の表皮が開いて250フィートもの高さを誇るグラン・ホールを外部へ見せている。このグラン・ホールは垂直方向の移動における中心となる。ホールのセキュリティ・チェックポイントから，訪問者はオフィス・タワーに向かうダブルデッキ式高速エレベータを配置した2層のエリアへと進む。タワーの66階には一般客にも開かれた空中レストランと展望テラスがあり，270度にわたって広がる壮大な眺望を提供する。このプロジェクトは全体として，正味146,988平米（1,582,166平方フィート）延べ面積で164,185平米（1,767,273平方フィート）の規模となっている。

タワー頂部はアンテナと風力発電のタービンの一群が覆い，電力を生産して，比喩的な空中の庭とも言える場所となっている。建物の形状と向きは太陽の日周運動に対応している。平面的で透明なガラス面による北側ファサードは，一年を通じた自然光の屋内日射を最大化している。タワーの南面，東面，西面のガラス面によるファサードは，斜め方向に編み上げられたステンレススティール製のメッシュパネルが曲線的な2次的な表皮として連続して覆い，熱取得と室内における眩しさを最低限に抑えながら，エネルギー効率を最適化している。

Detail: facade

Atrium

Kuala Lumpur Towers

2008 Kuala Lumpur, Malaysia

EOS Tower: A Global Landmark

The EOS tower emerges organically from Kuala Lumpur's urban fabric to become, by virtue of its bold form-fluid and sinuous, a landmark in the regional skyline and a visionary model for 21st century high-rise buildings. Informed by a commitment to sustainability, connectivity, and interdependence, the EOS Tower integrates program, design and engineering in a building that engages intelligently with its unique environment. The building's form, orientation, and skin respond to the tropical climate, focus views towards the adjacent Petronas Twin Towers, and connect with the dynamism of the city. Named for the Greek goddess of the dawn, who symbolically brings forth the new day, the EOS Tower will distinguish itself internationally as a beacon of optimism and progress.

An Icon that Engages the City

The site's unparalleled views and unique urban context drive both the form and the orientation of the EOS Tower. The eastern facade of the new high-rise curves inward to focus its gaze on the Petronas Twin Towers. The C-shaped tower turns and symbolically embraces the Petronas Towers, an honorific gesture that engages the city's celebrated landmark.

Sinuous, shimmering strands lyrically wrap the tower's glazed facade, visually alluding to and reinforcing the dynamism of the city. As the strands, or ribbons, move laterally across the tower, striations that begin in tight parallel formation at the building's thin, northeast edge, intertwine and deflect towards the middle of the facade to create openings for light and views, and finally unfurl as they reach the building's southern edge, expanding on this sense of openness and transparency. As the ribbons spiral down towards the base of the tower, the building extends its reach—the ribbons articulating the facade become form and space creating both a functional pedestrian bridge and iconic gateway for the development—the ribbons literally branch out from the tower volume, weaving into the fabric of city. This distinctive facade design is not only iconic; it is also integral to the building's energy efficiency and high performance, intelligently modulating the building's relationship to the tropical sun as described in the Integrating Sustainability section below.

The lower retail, hotel and residential lev-

Diagram: program analysis

els are organized around a grand lobby—a soaring 16-story space, capped with a faceted glass skylight. The skylight's folded glass membrane extends up the building's eastern facade, to provide dramatic perspectival views from the lower levels up towards the Petronas Towers. Beneath the crystalline membrane, a series of voids penetrates the retail, hotel and residential floor plates, bringing natural light into the lower levels.

Additional strategies that afford a variety of striking vantage points of the Petronas Twin Towers and the city of Kuala Lumpur throughout the project include:
- The boutique hotel is organized around a single loaded corridor and oriented to provide every hotel suite with privileged views of the Towers. The hotel pool deck cantilevers, extending partially beyond the building, to offer panoramic views of the city. Glazed volumes project from select residential units, allowing habitants to experience the sensation of floating high above the city. A large aperture in the high-rise's eastern facade opens up a view corridor from the lower level offices, through the hotel, to the Towers beyond.
- The office spaces and west-facing residential units are oriented to provide views of Menara Kuala Lumpur.
- Sky gardens, affording spectacular vistas of the city, are distributed vertically throughout the tower, providing informal spaces for habitants to congregate, socialize, and relax.

The formal articulation of each of the program areas—boutique hotel, office, residential, and pedestrian bridge—breaks down the scale of the tower and allows for a thin, elegant profile. The building volume separates between the office and hotel masses, creating a vertical slot that brings natural light into the workspaces and hotel corridors. Crowned with a distinctively sculpted void, the EOS Tower's profile is instantly recognizable in the Kuala Lumpur skyline.

Urban Connectivity
The EOS Tower emerges out of the dynamic urbanism that defines Kuala Lumpur. At the moment where the tower's base meets the city, its form unfurls, transforming into a pedestrian bridge that reaches out to forge connections with the Kuala Lampur City Center (KLCC). The scheme intensifies connectivity, encouraging multiple movement flows between the KLCC and the EOS Tower, and transforming the street level into a vibrant public space. In place of an autonomous tower, this hybridized building engages in and contributes to the life of the city.

Spaces transition from horizontal to vertical—offering a richness of cultural and commercial encounters along the way. Circulation, approach and entry sequences are carefully choreographed to afford a series of dynamic experiences and views as the visitor, inhabitant, or employee moves through the tower:
- Approaching from the port cochere or the pedestrian bridge, the visitor emerges into the main lobby, conceived as a grand public plaza in the air.
- Dedicated elevators service the secured residential parking, conveying habitants directly to their floor, with no stops.
- Escalators lead from the grand lobby up to the retail levels, traversing the lobby's soaring volume and affording a dynamic experience of the space.
- As habitants move through the retail levels and the hotel and residential lobbies, they can gaze up into the atrium to catch glimpses of shimmering water, though windows at the edge and underside of the cantilevered pool overhead.

Integrations Sustainability
Many of the same design decisions that create high-quality spaces also maximize energy efficiency. In response to the tropical climate, the facade's combination of opaque bands and transparent glazing provide optimal protection from the sun. The interweaving bands not only shade the interior to minimize heat gain, but also selectively separate to admit diffused natural light and to afford stunning views. Like a protective coating, this striated skin offers a high level of performance, unattainable with conventional floor-to-ceiling glazing.

The EOS Tower will incorporate ecologically responsive, indigenous landscape throughout. Native plant species drawn from the rich ecology of Southeast Asia will complement the built environment. The vertically distributed sky gardens will each be uniquely landscaped, featuring plant materials that thrive in the microclimates of the specific elevations in which each sky garden is situated. Pervious hardscaping will be used judiciously to collect surface and storm water run-off from rooftops and hardscaped areas.

EOSタワー：グローバル・ランドマーク
EOSタワーはクアラルンプールの都市的な構成から有機的に立ち上がり，流動的でしなやかに波打つその力強い形態を活かしてこの地区のスカイラインにおけるランドマークとなり，また21世紀の高層建築に向けて明確なヴィジョンを持つ一つのモデルとなる。持続可能性や接続性，相互依存性といった考え方への真摯な取り組みから得られた情報を基に，このユニークな立地環境に対して高い理解度をもって関わっていけるよう，このEOSタワーのプログラム，デザイン，そして技術を統合している。建物の形態やその位置付け，表層の処理に関しては，この地の熱帯性気候に対応し，建物からの視界を隣接するペトロナス・ツイン・タワーの方向へ集中させ，都市の活力へと結びついていくよう考慮している。象徴的な方法で新たな一日をもたらすギリシャ神話の暁の女神，エーオースにちなんで名付けられたこのEOSタワーは，最善を尽

North view

Site plan

6th floor

1 ENTRY COURT
2 RETAIL
3 RESIDENTIAL PARKING
4 PARKING
5 OFFICE LOBBY
6 OFFICE
7 HOTEL
8 RESIDENTIAL
9 SKY GARDEN
10 RESIDENTIAL LOBBY
11 PENTHOUSE

Ground floor

65th floor

40th floor

20th floor

くして得られる進歩や希望に満ちた前途を照らす国際的な灯火として認識されるようになるだろう。

都市と関わり合うアイコン

比類のないこの敷地からの眺望や独特の都市的文脈が，EOSタワーの形態や建物の位置付けを決定する際の牽引要素となる。この新しい高層建築の東側ファサードは内側に向けてカーブを描き，ペトロナス・ツイン・タワーへの眺望を方向付けている。C型のタワーは，象徴的にペトロナス・タワーを抱き込むようにして立ち，この街の名高いランドマークであるペトロナス・タワーに対して敬意を表しながら関係性をつくる。

しなやかに波打ち，揺らめくような撚り合わせの形状が，タワーのガラス・ファサードを詩的な表現で包み，都市のダイナミズムを視覚的にほのめかしつつ強化する。薄くなった建物の北端からは，平行に走る密な細い筋が撚り合わせの縄，あるいはリボンのようにタワー表面を斜め方向に動きながら撚り合わされ，ファサード中央部に向かって屈折することで採光と視界のための開口を作り出す。そして，最終的には建物の南端に到達したところで広がって，開放性や透明性といった感覚を与えながらその裾野を広げている。リボンはタワーの基部に向かって螺旋状に下りながら，建物はその伸びる方に向かって拡大していく――そして建物のファサードを構成するリボンは，機能的な歩行者用ブリッジと同時に，この開発全体の象徴的な玄関口となるような形態と空間をつくり出す――そしてリボンはタワーのヴォリュームから枝分かれして，都市の構造の中へと編み込まれていく。この独特のファサードは図象的であるだけでなく，建物の高いエネルギー効率性と性能を得るために不可欠なものであり，「接続性」について総合的に説明された下記に示す方法により，建物と熱帯の太陽光の関係を処理された情報に基いて調節している。

建物低層部の商業エリア，ホテル，居住エリアは，切子状になったガラスの天窓で覆われており，16階層分にもわたってそびえる大きなロビーの周りに配置されている。天窓の屈曲したガラス面は，東側ファサードに向かって伸び上がり，下層部からペトロナス・タワーに向けて，大きく開ける劇的な眺望を提供している。この結晶状の境界面の下では，商業エリアやホテル，居住エリアが積層する中に様々な空隙が挿入され，自然光が下層レベルにも届くようにしている。

ペトロナス・ツイン・タワーやクアラルンプールの市街への素晴らしい見晴らしを提供する様々な場所をもたらすためのその他の方策は，以下の通りである。

・質の高い小規模のホテルは，片廊下に沿うように部屋が置かれ，全てのスイートからペトロナス・タワーへの特権的な視界を提供できるように配置されている
・ホテルのプール・デッキは建物から一部片持ち状に張り出して，都市のパノラマ景観を提供する
・いくつかの住宅ユニットではガラスのヴォリュームが建物から突き出しており，居住者は都市の空高く浮遊する感覚を経験できる
・オフィスと西側に面した住宅ユニットはメナラ・クアラルンプール・タワーへの展望が開けるよう配置されている
・都市への素晴らしい眺望を提供するスカイガーデンは，タワーの垂直方向にいくつも配置され，居住者が社交の場として，またくつろぐ場として気軽に集まることのできる空間を提供している

ホテル，オフィス，住居，歩行者用の連絡橋といった各プログラムエリアは形態的に分けて表現され，タワーのスケール感を分解し，薄く，エレガントな建築の輪郭をもたらしている。建物ヴォリュームはオフィスとホテルの量塊に分離され，オフィスとホテルの廊下に自然光を取り込む垂直方向の隙間を作り出している。独特の形状になっている空隙を頂部に抱き，EOSタワーの輪郭はクアラルンプールのスカイラインの中でも瞬時に見分けられる。

都市への接続性

EOSタワーは，クアラルンプールを特徴付けるダイナミックな都市空間の中から立ち上がっている。タワーの基部が都市部に到達した部分からすぐに，その形態はクアラルンプール・シティセンター（KLCC）へと弛みなく進み接続する歩行者橋へと変形し，広がっていく。このデザインは「接続性」の考えを強化し，KLCCとEOSタワーとの間で複数の動きの流れが生み出されるのを促して，地上レベルを活発な公共空間へと変容していく。「自律的なタワー」という従来の考え方に代わり，この複合的な建物は都市の生活と関連し合い，それに寄与していく。

様々な空間が水平的なものから垂直的なものへ変化していき，その変化の中で文化的にも商業的にも多様な邂逅を提供している。動線からアプローチ，入口というシークエンスは綿密に構成され，訪問者や居住者，従業員達がタワー内を移動する際にダイナミックな経験や眺望を以下のように提供する。

・車寄せや歩行者橋からのアプローチの際，訪問者は空間に浮かぶ壮大な公共空間といった趣のメインロビースペースに浮かび上がっているかのような経験になる
・居住者専用エレベータが，警備された居住者用駐車場から住居フロアへ，ノンストップで運ぶように運用される
・エスカレータがグランドロビーから商業空間レベルへと伸び，ロビー上にそびえる空間内を横切ることで，ダイナミックな空間経験を提供する
・居住者が商業空間レベルとホテル，居住者用ロビーの間を移動する際に吹き抜けを見上げると，キャンティレバー状になっている頭上のプールの端部と下方にある窓からは，水の揺らめきが垣間見える

持続可能性（サステイナビリティ）の統合

質の高い空間を作り出す数々のデザイン決定に際しては，エネルギー効率を最大化することを考慮している。熱帯性の気候に対応するために，不透明な帯状要素と透明なガラス面を組み合わせたファサードは太陽光から保護する際に最適解をもたらすものとなっている。編み上げられた帯状の要素は建物内部空間の熱取得を最小限にするよう陽を遮るだけでなく，必要に応じて拡散された自然光を取り込み，さらに素晴らしい景観を提供することを可能にする。保護皮膜のように，この細い筋状の皮膜はフロア面から次のフロア面まで全てガラス面になった従来のスキンでは達成できない高いレベルの性能を発揮する。

EOSタワーは生態学的にこの敷地に適応し，地元固有のランドスケープ空間についてもプロジェクト全体を通じて一体化される予定である。東南アジア地域の豊かな生態系の中からもたらされた地元固有の植物達はこの新しく生みだされた環境を引き立てることだろう。垂直方向に分配された空中庭園には，それぞれ特有の植物が植えられ，その繁茂のために庭園内部は特定の気候条件と室内高が設定されることで，各庭園は独自のランドスケープを与えられている。屋根や庭園に落ちる雨水や表流水を集めるため，浸透性の人工材料を注意深く用いている。

South elevation

West elevation

View from southeast

Atrium

Taipei Performing Arts Center

2008-09 Taipei, Taiwan, R.O.C.

"I believe that in a great city... a great theater is the outward and visible sign of an inward and probable culture."
by Sir Laurence Olivier/British actor, director and producer (1907–1989)

Historically, Taiwanese culture has encompassed a rich blend of Confucian Han Chinese, Japanese, European, American, southern Asian, and indigenous influences. This diversity, combined with Taiwan's ongoing social and political struggle for self-determination, has forged a strong, distinctive and resilient national identity.

In the spirit of Taiwan's time-honored cultural diversity, and its more recent social and political resilience, the Performing Art Center embodies a series of contrasts and counterpoints:

Urban Connector and Iconic Jewel
The Performing Arts Center stands out as an icon, its facets immediately identifiable from all corners of the city. Simultaneously, the complex is at one with its urban environment—seamlessly connected to its immediate surroundings, via public plazas, 24-hour linkages, dynamic facades and covered arcades. The complex is monumental in stature yet grounded in its context.

Quotidian and Symbolic
The Performing Arts Center embraces Taiwanese culture's reverence for the theater as a fundamentally open art form. The Center is conceived not only as a ceremonial setting for theater as high art, but moreover as an inclusive "People's Theater" that is woven into everyday life. Theater-goers, visitors, and passersby alike engage as both participant and observer in the public spectacle facilitated by the center's overlapping variety of spaces.

Regional Landmark and International Destination
While specific to its local context, the Performing Arts Center provides a state-of-the-art, world-class facility, equipped to meet the highest international artistic standards. The project anchors Taipei's new cultural axis and elevates Taiwan as a global nexus of cultural and social distinction.

Taipei epitomizes the boundless potential of the city, that most profound creation of humanity; it is the location of continuous regeneration, and a place of infinite possibilities. In the broadest sense, the new Performing Arts Center becomes the "great theater" that is "the outward and visible sign" of this great city.

Urban Connectivity
Our proposal creates an environment that, amidst the dynamism and cacophony of the city, functions as a universe unto itself, while also seamlessly integrating with the physical, social and cultural fabric of its immediate context. Within walking distance of the lively Shilin Night Market, the historic Cixian temple, and the Zhongshan North green boulevard, as well as the TRTS Jiantan Station and major roadways, the Taipei Performing Arts Center anchors a round-the-clock cultural axis. The architecture becomes, by virtue of its sculpted and indelible form, a landmark in the region—like a jewel, with distinct facets visible from all corners of the city.

The Role & Organization of the New Performing Arts Center
In Taipei, the theater is not an amenity reserved for the cultural elite, but is truly open to the entire community. Our proposal celebrates both conceptions of theater: theater as high art, embodied by the sumptuous formal foyers leading to the striking Grand Theater and the intimate Proscenium Playhouse; and the inclusiveness of a "People's Theater," exemplified by the Multiform Theater's overt and deliberate connection to the public. The differentiated form, material language, and spatial layout of each of the three theaters align with their respective roles. Each theater's distinct form in turn directly inflects the form of the overall building envelope and the complex as a whole.

Public Spaces: Life as Theater
Responding to Taipei's culture of inclusiveness in the theater, the new Performing Arts Center is literally a theater "of the people." In the tradition of Garnier's Paris Opéra and Sharon's Berlin Philharmonic, life becomes theater. In the public spaces, visitors become part of the theater everyday as they move through the complex, themselves on display and engaged in the public spectacle. The complex's public and semi-public spaces, such as atria and entry foyers, are oriented to face the city, overlooking Jiantan Station and the vibrant intersection across from the night market. Expansive planes of glass arc across the outward-reaching metallic façade, propelling the complex's public spaces into the city.

Formal Entry Sequence: A Transition from Daily Life to the World of Theater
The formal entry sequences leading to the Grand or Proscenium Playhouse Theaters convey the civility, cosmopolitan nature, and symbolism of the theater. The spatial layout composes a ceremonial experience for the theater- or operagoer: from the street level box offices, the guest ascends to the grand atrium—an impressive volume, animated by tiered foyers, escalators and glass sky bridges; the guest is directed to the proper foyer tier to access his seat; he then traverses a glass sky bridge to enter the pristine sculptural form of the theater—transported into the captivating world of the performance. At intermission, guests emerge from the theater, to dine at their reserved table in the grand atrium's piano nobile (the elevated main floor) themselves becoming part of the public spectacle—the "theater within theater."

Grand Theater: A Rarified Experience
A smooth, lustrous ovoid form houses the Grand Theater, the largest of the complex's three theaters. This state-of-the-art theater is equipped to accommodate international opera and traveling shows. The two levels of balconies, refined form, and lush material palette, render the theater a truly grand, awe-inspiring scale and character.

Proscenium Playhouse: An Intimate Experience
In contrast to the impressive scale of the Grand Theater, the Proscenium Playhouse, which houses primarily national theater and music performances, affords an intimate experience of the performance. The space is compressed, with balconies recessed into the walls and a tapered ceiling, to intensify the connection between audience and performers.

Multiform Theater: Connected to the Community
The Multiform Theater is the most flexible, inclusive and open of the three theaters; it becomes part of the life of the street, in the local tradition of impromptu street performance. Submerged below grade, the theater can fully open up to draw the public directly in from the street, via the grand entry stair. The entire theater—stage, seating, and ground plane—is built onto lifts, to afford complete flexibility. The Multiform can be arranged to house stadium seating, theater in the round, or a range of other configurations. The lifts allow the slope of the tiered ground plane to align with the angle of the grand stair from the street, in a configuration that also allows the theater to function as an unimpeded public community space.

© Michael Powers (*)

Second floor

Site plan

First floor

Forth floor

1	FOYER	12	OTHERS	22	PROGRAMMING
2	PUBLIC SPACE	13	SECURITY	23	BOX OFFICE/ SHOPS
3	FORE STAGE	14	ELECTRICAL CONTROL CENTER/ CLOAK ROOM	24	CIRCULATION
4	ORCHESTRA PIT			25	PARKING FACILITY
5	FRONT DESK	15	FRONT DESK	26	CAT WALK
6	STAR CHANGING ROOM	16	INFORMATION BOOTH / RESTROOM	27	STAGE
7	MULTIMEDIA CONTROL ROOM	17	SERVER MACHINE ROOM	28	REAR STAGE
8	LIGHTING/SOUND CONTROL ROOM	18	OPERATING OFFICES	29	GRAND THEATER
9	LARGE DRESSING ROOM	19	ARTISTIC DIRECTOR'S OFFICE	30	OPERABLE GLASS WALL
10	MEDIUM DRESSING ROOM	20	MAINTENANCE SERVICES OFFICE	31	BALCONY
11	RECEPTION AREA	21	MANAGER'S OFFICE	32	ADMINISTRATION

Urban context

Diagram

West elevation

East elevation

74

SUSTAINABILITY FEATURES

DOUBLE SKIN FACADE
SOLAR POWERED JUMBO SCREEN
POROUS PAVING
SHARED MECHANICAL DISTRIBUTION
RAIN WATER COLLECTION
PLANTED GREEN ROOF
HEAT RECOVERY SYSTEM
PHOTOVOLTAIC PANELS
ICE STORAGE ROOM

THEATERS AND STAGES

PROSCENIUM PLAYHOUSE THEATER STAGE AND FLY TOWER
MULTIFORM THEATER
GRAND THEATER
PROSCENIUM PLAYHOUSE THEATER
GRAND THEATER STAGE AND FLY TOWER

Cross Section 1

Cross Section 2

Cross Section 3

1 FOYER	12 OTHERS	23 BOX OFFICE/ SHOPS
2 PUBLIC SPACE	13 SECURITY	24 CIRCULATION
3 FORE STAGE	14 ELECTRICAL CONTROL CENTER/CLOAK ROOM	25 PARKING FACILITY
4 ORCHESTRA PIT	15 FRONT DESK	26 CAT WALK
5 FRONT DESK	16 INFORMATION BOOTH / RESTROOM	27 STAGE
6 STAR CHANGING ROOM	17 SERVER MACHINE ROOM	28 REAR STAGE
7 MULTIMEDIA CONTROL ROOM	18 OPERATING OFFICES	29 GRAND THEATER
8 LIGHTING/SOUND CONTROL ROOM	19 ARTISTIC DIRECTOR'S OFFICE	30 OPERABLE GLASS WALL
9 LARGE DRESSING ROOM	20 MAINTENANCE SERVICES OFFICE	31 BALCONY
10 MEDIUM DRESSING ROOM	21 MANAGER'S OFFICE	32 ADMINISTRATION
11 RECEPTION AREA	22 PROGRAMMING	

「偉大な都市における偉大な劇場の存在とは，精神的で未来に向け有望な文化という存在を，肉体的で目に見えるものに記号化したものであると信じている」
サー・ローレンス・オリヴィエ（1907〜89年，英国の役者，監督，プロデューサー）

歴史の流れの中で，台湾の文化は，儒教による漢文明の中国，日本，ヨーロッパ，アメリカ，南アジア，そして古来土着の影響などとの豊かな混合と調和を成し遂げてきた。今もなお政治的葛藤はこの多様性と相まって，力強く独特で，回復力のある台湾という国の独自性を鍛えあげてきたと言える。

台湾の持つ，古くから続いてきた文化的多様性に根ざした精神と，より現代において見られる社会的，政治的弾力性の中で，この舞台芸術センターは台湾の持つ一連の差異や対称性を体現しようとしている。

〈都市の結節装置であり，かつアイコン的な宝石〉
舞台芸術センターの切子状になった形状はどの街角からもすぐにそれと識別でき，アイコンとして傑出した存在となる。同時に，公共広場や，1日24時間可能なアクセス性，ダイナミックなファサードや屋根付き回廊などによって，周辺の状況と継ぎ目なく繋がり，この複合施設は台北の都市的環境と一体となる。その姿においては記念碑的でありながら，文脈的には敷地周辺の中に根付いている。

〈ありふれていながら，かつ象徴的なもの〉
この舞台芸術センターは，演劇を最も根源的なものとして尊崇の念を抱いて扱う台湾の文化を受け入れるものとなっている。この芸術センターはハイ・アートとしての舞台芸術が持つ儀礼的な背景を体現している

だけでなく，それ以上に「人々の劇場」として日常生活に織り込まれたものとなるよう，全てを含んだ包括的なものとした。

舞台芸術の愛好者，訪問者，そして一般の通行者の誰もが参加者として，あるいは傍観者として，芸術センターを中心に構成された様々な空間的仕掛けによって繰り広げられる，一連の公共スペクタクルに関わっていくことになる。

〈地域的なランドマークでありながら，かつ国際的な目的地となるもの〉
敷地と周辺地域の文脈に特化しながら，この舞台芸術センターは最高度の国際芸術施設基準を満たす設備を備え，世界一流レベルの最先端の施設を提供する。このプロジェクトは台北の新しい文化的基軸をこの地にしっかりと結びつけ，文化的，社会的独自性の集合体として世界的な意義を持つ台北をさらに昇華させる。

台北は人間の造り出してきた物の中で最も意義深いものとして，都市の限りない可能性を縮図的に示している。この地は途切れることのない再生の場所であり，そして無限の可能性を意味する場所でもある。あらゆる意味において，新しい舞台芸術センターは，この偉大な都市の「肉体性を持った，目に見える記号」としての意味を持つ「偉大な劇場」になることだろう。

都市空間における接続性
我々の提案は，都市の躍動と騒音の只中に，それ自体で完結した世界として機能しながらも，周辺の持つ物理的，社会的，文化的広がりとも途切れることなくつながっていく環境を創りだすものである。活気ある士林の夜市場や長い歴史を持つ慈恵宮，中山北路，そして台湾地下鉄剣潭駅や主要幹線

道路から歩ける距離に位置することになる台北舞台芸術センターは，こうした24時間不眠不休の文化的な基軸をつなぎ止める。小平面で形成された彫刻で強い印象を残す形態を活かし，街の全ての場所からはっきりと認識できる宝石のような建築として，この地のランドマークとなっていく。

新しい舞台芸術センターの役割と構成
台北の中にあって，この劇場は文化的エリートのために確保された娯楽施設ではなく，全ての地域コミュニティに対して開かれたものである。我々の提案は，豪華で形式的なホワイエから印象的なグランド・シアターや親密な距離感を持ったプロセニウム劇場によって体現されるハイ・アートとしての舞台演劇の概念と，意図的に大衆へのつながりを明らかにしている多用途劇場に示されるような包括的な「一般人の劇場」としての概念の双方を喧伝している。各々に差異化された形状や，使用材料の体系，三つの劇場の空間配置といった要素はそれぞれの役割に合わせて決定されている。各劇場の個別に異なった形体は，劇場を内包しこの複合施設全体を形づくる形状に対し，直接に影響を及ぼしていく。

〈公共空間：劇場的な人生〉
台北の劇場を取り巻く文化に対応することで，この新しい舞台芸術センターは文字通り「人々の劇場」となる。シャルル・ガルニエによるパリ・オペラ座や，ハンス・シャロウンによるベルリン・フィルハーモニーといった劇場の伝統に倣い，人生そのものが劇場の一幕となる。来訪者はこの複合施設内の公共スペースを移動することで，この劇場の日常の一部となり，来訪者自身が公共的なスペクタクルの一部として劇場に関わっていくことになる。アトリウムや

入口部分のホワイエといった複合施設内の公共スペースと半公共スペースは街に向けて配置され，剣潭駅や夜市を挟んで向かいに位置する交差点の活発な雰囲気を見下ろしている。外部に向かって伸びていく金属製のファサードには円弧を描く開放的なガラス面が掛かり，この施設の公共スペースを都市に向かって拡張していく。

〈フォーマルな来場のシークエンス：日常生活から劇場の世界への移行〉
グランド・シアター，もしくはプロセニウム演劇場へと続くフォーマルな来場のシークエンスは，丁重に国際人的な雰囲気や，この劇場の持つ象徴性を表現するものとなる。広がりのある空間構成と配置によって，劇場の――あるいはオペラファンの――儀礼的な体験を創り上げていく。道路レベルの地上階にある切符売り場から，来訪者は堂々としたヴォリュームを持ち，階段状に層になったホワイエやエスカレータ，ガラスの空中接続ブリッジなどに生気を与えられた壮大なアトリウムへと昇っていく。来訪者は自分の席に至るための然るべきホワイエ階へと直接導かれる。そしてガラスの空中ブリッジを渡って，彫刻的で無垢な形状の劇場の中へと入っていく――こうして来訪者は劇場公演の魅惑的な世界へと運び込まれることになる。幕間には来訪者が劇場から現れ出て，壮大なアトリウムのピアノ・ノービレ（上層階に持ち上げられたメインフロア）に予め確保されたテーブルで夕食をとることができ，彼ら自身もこの「劇場の中の劇場」において公共スペクタクルの一部となる。

〈グランド・シアター：日常と社会から隔絶された経験〉
滑らかで光沢のある卵型の形状が，この複合施設にある三つの劇場の中では最大とな

るグランド・シアターを内包している。この最先端の劇場は，国際クラスのオペラ世界公演の興業を行えるよう設備が整えられている。二つの階層にある洗練された形状のバルコニーや華々しい素材のパレットなどが，まさに壮大で，荘厳なスケールと雰囲気をこの劇場に与えている。

〈プロセニウム劇場：親密な距離感を持った経験〉

グランド・シアターの堂々としたスケールとは対照的に，主に台湾の伝統的演劇や音楽演奏の公演が行われることになるプロセニアム劇場では，パフォーマンスとの親密な距離感を経験できるようになっている。この劇場空間は観客と公演者の間のつながりを強調するために，バルコニー席が壁から奥まって並び，先細りになった天井によって凝縮された空間となっている。

〈多用途劇場：地域コミュニティとの結束〉

多用途劇場は三つの劇場の中で最も柔軟性のある，包括的で開かれたものである。この土地の伝統である即興的なストリート・パフォーマンスの延長として，街路におけるこうした日常生活の一部となっていくよう意図されている。地盤面よりも埋め込まれた劇場空間は完全に開放され，大階段を通って街路から直接公共の人々を呼びこむことができる。ステージや客席，そして地表面といった劇場全体を構成する要素は昇降床の上に組み上げられており，劇場利用に際し完全な柔軟性を提供する。多用途劇場はスタジアム状の客席配列や円形劇場，その他様々な状態に配置することができる。この劇場空間が公共のコミュニティ空間として機能する妨げとならないよう，劇場に設置されたリフトは，階段状になった客席床面の傾斜を，街路から続く大階段の角度に揃えることもできる。

Seoul Performing Arts Center

2008–09 Seoul, South Korea

Night view

North elevation

South elevation

78

East elevation

West elevation

Site plan

First floor

An Integrated Cultural and Ecological Vision for Seoul

The new Performing Arts Center is poised to become the universally recognized icon for Seoul, one that is synonymous with Seoul's dynamic identity. The Center serves as a powerful symbol—one that evokes an instantaneous and indelible impression of Seoul as a global steward of the environment and culture, with an optimistic vision and commitment to the future.

The Han River has represented the symbolic center of Korean culture, economics and politics, since Seoul's designation as the capital of the Chosun Dynasty over six centuries ago. The unique symbolism and position of Nodul Island, at the heart of contemporary Seoul, is the impetus for our design. The scheme is unequivocally unique to the ecology and topography of its site: it redefines the site boundaries to encompass the whole island, incorporates a nature preserve as an integral part of the design, and brings the surrounding water onto the site. Beyond simply a proposal for a building complex, the comprehensive design for the new Seoul Performing Arts Center (SPAC) transforms the entire island into a world-class cultural destination and an ecological haven.

Iconic Jewel and Urban Connector: A World-Class Performing Arts Destination

Positioned, literally, at the heart of Seoul, the SPAC connects the social and cultural fabric on both sides of the Han River—the Gangbuk historical city north of the river with the Gangnam newer development south of the river. The architecture becomes, by virtue of its sculpted and indelible form, a civic jewel in the river, with distinct facets visible from all corners of the city. From the banks of the Hangang and vantage points throughout Seoul, the SPAC appears to shift continually—not a fixed image but rather a dynamic structure that responds to its site, environment, and time of day. The SPAC's form bifurcates to house the distinct volumes of the two performance halls: the northern Opera Theater and the southern Symphony Hall. From the Gangnam (to the south), the primary view is of the undulating forms of the Center as they interact with and integrate with the surrounding landscape; from the Gangbuk (to the north), the SPAC's reflective forms reach out over the water, to establish a distinctive and iconic civic landmark. The SPAC transforms diurnally: by day, its skin appears reflective, shimmering with light bounced off the water, while by night it appears to glow, its translucent skin revealing the activity within.

When a visitor crosses onto the island, he transitions from his daily urban life to the ceremonial experience of performance, to the respite of the nature preserve. From the island, the visitor enjoys both the new Center's cultural assets and nature preserve, while simultaneously experiencing a unique perspective on the river and the city beyond.

A Dynamic Arrival: Public Plaza & Great Canyon

Our scheme incorporates a new public plaza—a valuable asset to the city of Seoul that reinforces the SPAC as a civic destination. Approaching from Han River Bridge, the public plaza welcomes visitors and provides an outdoor space for groups to congregate. From the plaza, visitors enjoy views of both the Center to the east and the sweeping landscape to the west.

The dynamic arrival sequence incrementally reveals spectacular views of the water, the performance halls, and the natural terrain. From a recessed drop off point, the visitor ascends across the gently sloping plaza to arrive at the new Performing Art Center's grand entry. At this moment, the forms of the two performance halls converge. The visitor slips between the surging forms into the main lobby, as if passing through a dramatic natural canyon that frames a long view of the water. Alternately, prior to formal entry into the Grand Lobby, the visitor can proceed directly up to the SPAC's Studio Theater or restaurant.

Gracious Promenade to the Eco-Park

A rooftop promenade takes performance-goers and the public from the Performing Arts Center to the Eco-Park and the Amphitheater on the western side of the island. From the top-floor restaurant, the visitor traverses the green roof, via an exterior promenade. Small shops, studios and a learning center line the promenade as it passes over Han River Bridge. The promenade then

1	BACKSTAGE SPACE	13	RAISED LANDSCAPE	25	STAGE PLATFORM
2	ARTIST SUPPORT	14	STAGE ENTRANCE	26	CONCERT HALL
3	REAR STAGE LIFT PIT BELOW	15	LOADING	27	MAIN OPERA LOBBY
4	MAIN STAGE LIFT PIT BELOW	16	SCENERY ASSEMBLY AREA	28	MAIN CONCERT LOBBY
5	SCENERY STORAGE BELOW	17	REAR STAGE	29	DRESSING ROOMS
6	SIDE STAGE BELOW	18	OPERA STAGES	30	CHORUS REHEARSAL
7	ORCHESTRA PIT	19	MAIN STAGE	31	TECHNICAL STAFF ROOMS
8	SUPPLY AIR PLENUM	20	FULL SIZE REHEARSAL ROOM	32	FULL SIZE REHEARSAL ROOM BELOW
9	ELEVATOR BANK TO ENTRY PLAZA	21	SIDE STAGE	33	REHEARSAL AND ARTIST SUPPORT
10	MECHANICAL	22	OPERA THEATER	34	CONCERT LOBBY BELOW
11	DOUBLE HIGH MECHANICAL	23	GRAND LOBBY	35	OPERA LOBBY BALCONY
12	CAFE/BAR	24	GRAND LOBBY SERVICE	36	PRACTICE ROOMS AND ARTIST LOUNGES

Second floor

Third floor

splits into three paths leading to the Eco-Park's three zones, rendering the entire island accessible to the public.

Symbiotic Relationship Between Building, Landscape and Water

Our proposal creates an environment that functions as an ecological and cultural oasis—a complementary counterpoint to Seoul's dynamism and intensity. Our scheme augments the Nodul Island landscape with a new Eco-Park and integrates with the surrounding water, to offer city dweller and international visitor alike a natural respite from one of the world's most populous and vibrant urban centers. The SPAC's architectural forms move into and out of the island's sculpted terrain, interweaving building with landscape and built environment with site. The design not only affords a valuable natural public amenity, but also maximizes energy efficiency and the responsible use of resources for the Performing Arts Center, extending the City's ongoing sustainable initiatives.

Integrating Water

The scheme fundamentally re-shapes the island, bringing water onto the site to integrate with the architecture, accentuating the island's symbiotic connection to the river. At the eastern tip of the island, the barrier of the low sea wall defines a permanent, controlled reflecting pool, visually connected with the river via an infinity edge. The Eastern faceted glass façade cants forward to capture shimmering light reflected off the surface of the pool. A series of public gathering spaces overlook the reflecting pool, giving visitors a more direct and visceral experience of the water.

Water also plays a key role in the SPAC's cutting edge sustainable systems: to condition the building and maximize energy efficiency, water from the building passes through a pipe submerged in the river, where it is cooled and used as a heat pump. A separate system collects rainwater and grey water, and distributes it to the nature reserve, where plant species and ground materials naturally filter the water. The cleaned water then moves on to the reflecting pool, and finally flows over the infinity edge back into the river.

An Ecological Haven

By concentrating the program areas for the SPAC and the Music Park for Youth around the Han River Bridge, the scheme cedes the remaining open space for an extensive nature preserve. The Eco-Park comprises three landscape zones, each accessible to the public via promenades and paths.

- The Great Lawn: Behind the Amphitheater, the manicured Great Lawn affords a more informal viewing area for the Music Park for Youth performances, and a recreational space when performances are not in session.
- Wetlands: The wetlands conform with the island's natural topography and function as a key sustainable component. The wetlands maintain habitat for the island's endangered toad, and facilitate the water management and natural filtration system.
- Wooded grasslands: Woods and grasslands ring the western tip of the island, providing a shaded natural destination just outside the city.

Our proposal capitalizes on the unique attributes of the site—its topography, its waterfront, its singular views of Seoul, its symbolism and history—to create an international landmark for Seoul. When complete, the new Seoul Performing Arts Center and Nodul Island will be completely and inseparably integrated, in a project that, like Utzon's Opera House for Sydney, will come to define the city of Seoul's rising cultural influence.

Night view of main entrance

〈ソウルのための文化と環境保護のビジョンの統合〉

この新しい舞台芸術センターは，ソウルのダイナミックな独自性と同義となるアイコンとして，世界的に認められるものとなる準備が整っている。未来に向けて最善を尽くすヴィジョンと真摯な取り組みを持ち，環境と文化的課題に関する世界的な世話役ともいうべきソウルの印象を，瞬時に，かつ消すことの出来ない痕跡をもって喚起する力強いシンボルとしての役割を果たすだろう。

漢江(ハンガン)は，ソウルが李王朝の首都として定められてから現在まで6世紀以上もの間，韓国の文化や経済，そして政治の象徴的な中心としての姿を表象してきた。このプロジェクトでは，現代のソウルにおいてその中心にあるノドゥル島の独自の象徴性と位置付けが我々の設計の起動力となっている。我々の提案は敷地の地形と環境に対して独自性を持つ明確な解を示したものだ。建築により島全体を取り囲んで敷地の境界を再定義し，設計の構成要素として保全された自然を建築に統合し，敷地周辺の水を敷地に取り込んでいる。複合施設のための建築提案という単純な枠組みを越え，多くの要素を理解しながら包括的に捉えたこの新しいソウル舞台芸術センター（SPAC）は，世界一流の文化の目的地として，また環境における安息の地としてこの島全体を変容していくものとなる。

〈アイコニックな宝石として，都市的な接続装置として：世界一流の舞台芸術目的地〉

文字通りソウルの中心に位置するSPACは，漢江の北岸に位置する歴史ある江北(カンブク)と，南岸に位置する新しい江南(カンナム)の両岸における社会的，文化的構成を接続する。この建築は明瞭な切子面を持ち，ソウルのどこの街角からも見える彫塑的で忘れ難い形状を活かして，河に浮かぶ市民の宝石となるだろう。漢江の両岸やソウル市街の様々な眺望ポイントから見ると，SPACは固定されたイメージというよりは，よりダイナミックな構造物として敷地や環境，さらに一日の時間の流れに対応して絶えずその姿を変える。SPACの形体は二つの個別の舞台ホール──北側のオペラ劇場と南側のシンフォニーホール──による各ヴォリュームを内包するために分岐している。江南（南岸）からの主な眺望は，周辺のランドスケープと影響し合い，かつ取り込んでいる舞台芸術センター建築の緩やかな起伏である。江北（北岸）からは，反射するSPACの

Diagram: program analysis

Main opera lobby

© *Michael Powers*

East elevation

Sections

形態が水辺に伸び，図像的でユニークな市民のランドマークを確立していく様が見渡せる。SPACは時間によってその姿を変える。日中にはその表皮は反射的で，水面に反射した光によって揺らめいているが，夜間にはその半透明の表皮が内部の活動を外部に現し，建物自体が輝いているように見えるだろう。

訪問者はこの島へと渡る際，都市の日常生活から芸術公演の儀式的な経験と，自然の保護区における都市生活の小休止へと移行していく。また訪問者はこの島での滞在により文化的な価値と保護された自然を楽しむと同時に，河の上からソウルの街とその先へのユニークな眺望をも経験する。

〈ダイナミックな島への到着：公共プラザ及び大きな谷〉

我々の提案では，SPACが市民の行き先であることを強調するため，ソウル市の価値ある財産としての新しい公共プラザを組み込んでいる。漢江橋を通ってアプローチする公共プラザは来館者を歓迎し，人々が集まることのできる外部空間を提供する。訪問者はこのプラザから東側にはセンターの建築，西側にはランドスケープへ広がる景観を楽しめる。

ダイナミックな到着のシークエンスに際しては，河やパフォーマンスホール，そして自然の地形への素晴らしい視界が徐々に開けて行く。来館者は奥まった場所にある車の乗降ポイントから緩やかに傾斜したプラザを昇り，この新しい舞台芸術センターの壮麗な入口に辿り着く。この瞬間から，二つのパフォーマンスホールの形状は一つに収束していく。訪問者は，河への視界を細長く切り取る劇的な自然の峡谷の間を通って行くかのように，このうねった空間をすり抜け，メインロビーへと進む。別のアプローチ方法として，グランドロビーへの正面入口から入る前にSPACの練習室もしくはレストランへ直接進むことも可能である。

〈エコパークへの優雅な遊歩道〉

屋上の遊歩道は舞台芸術公演の常連や一般来館者を，舞台芸術センターから島の西部にある屋外劇場のあるエコパークへと連れ出す。人々は最上階にあるレストランから外部遊歩道を通って緑化された屋根を横切る。漢江橋を渡る部分では小さな店舗や練習室，学習センターが遊歩道に沿って並んでいる。ここで遊歩道は三つの小路に分かれてエコパークの三つのゾーンへと続き，一般訪問者が島全体にアクセスできるようになっている。

〈建物とランドスケープ，河の間の象徴的な関係〉

我々の提案はソウルの活力と強度を引き立てるものとして，都市空間とは対照的なオアシスとして機能する空間を環境保護と文化の導入によって創造する。この建築案ではノドゥル島の景観を新しいエコパークによって増大させる。さらに島を取り巻く河川と一体化することで，世界でも最も人口密度が高く活気ある都市空間の中心部に，都市生活者だけでなく外国人訪問者の誰もが自然環境の中で小休止できるような場所を提供している。SPACの形は島の起伏のある地形に入り込み，あるいは抜け出して，建物をランドスケープと敷地の立地環境に織り込んでいる。この設計は公共のために価値ある自然環境を提供するだけでなく，エネルギー効率を最大化することで舞台芸術センター運用にかかる資源利用に対して責任を持ち，ソウル市が率先して進める持続可能性に関する進取の精神を拡張するものとなっている。

〈河水の統合〉

この案は河水を敷地に取り込み，建築と一体化させることで島と河とのつながりを強調し，根本から島をつくり変えていくものである。島の東端における背の低い防波護岸は，恒久的に制御された水庭を形成し，その際限のない境目と川面を視覚的に繋げている。建物東面の切子状になったファサードは，水庭表面で反射された光の揺らめきを捉えるために斜めに傾斜している。一連の公共空間のまとまりは，この水庭を見下ろしており，より直接的で感動的な水の経験を訪問者に提供する。

SPACでは，最新の環境対応システムに関連して，水はさらに重要な役割を果たす：建物の温度を調整し，エネルギー効率を最大化させるために，建物内を循環した水は河に沈められた配管の間を通り，ヒートポンプの仕組みによりその温度が下げられる。別系統のシステムでは，雨水と汚水を集め，自然保留地へと配給し，植生や土壌物質によって自然に水を濾過する。浄化された水はその後水庭へと進み，最終的には河との境目が分からないような縁から河へと流れこむ。

〈生態系の避難所〉

漢江橋の周囲にSPACと青年音楽公園のプログラム空間を集中することで，この案は残りの土地を広大な自然保護区として残していく。このエコパークは三つのランドスケープゾーンから構成されており，各ゾーンは遊歩道や小路を通じて一般訪問者にもアクセスできるようになっている

・グレート・ローン＝大きな芝地：屋外劇場の後方にある芝の手入れが行き届いたグレート・ローン芝地から青年音楽公園での舞台芸術公演を気楽に見ることができ，公演が行われていない時には気晴らしの空間となるよう芝地が提供されている

・湿地帯：この湿地帯は島の地形に順応して広がり，環境保護機能の重要な要素として機能する。湿地帯は島で迫害され危険にさらされたヒキガエルの生息地を保全し，さらに水管理と自然なろ過システムとして環境保全の手助けをする

・木の茂った草原：森と草原が島の西端を取り囲み，都市のすぐ外に市民の目的地となるような日陰のある自然環境を提供している

我々の提案は，ソウルに国際的なランドマークを生み出すため，敷地のユニークな特性——地形，その水辺の性質，ソウル市への唯一無二の眺望，象徴性や歴史など——を利用している。完成した暁には，この新しいソウル舞台芸術センターとノドゥル島はヨーン・ウッツォンによるシドニーのためのオペラハウスと同様，完全に，また密接に一体化され，ソウルの文化面での影響力の高まりを明示していくものになるだろう。

1 PARKING	12 MAIN STAGE
2 STUDIO THEATER	13 OPERA THEATER
3 RESTAURANT	14 GRAND LOBBY
4 OUTDOOR TERRACE	15 CONCERT HALL
5 FLY TOWER	16 MAIN CONCERT LOBBY
6 MECHANICAL	17 CHORUS REHEARSAL
7 SCENERY STORAGE	18 CONCERT LOBBY BALCONY
8 CAFE/BAR	19 OPERA LOBBY BALCONY
9 LOADING	20 ORCHESTRA REHEARSAL ROOM
10 SCENERY ASSEMBLY AREA	21 RETAIL
11 REAR STAGE	

Perot Museum of Nature & Science

2008-13 Dallas, Texas, U.S.A.

Site plan

Diagram: composition

POD

ROCK

LAND

Diagram: landscape concept

87

Museums, armatures for collective societal experience and cultural expression, present new ways of interpreting the world. They contain knowledge, preserve information and transmit ideas; they stimulate curiosity, raise awareness and create opportunities for exchange. As instruments of education and social change, museums have the potential to shape our under- standing of ourselves and the world in which we live.

As our global environment faces ever more critical challenges, a broader understanding of the interdependence of natural systems is becoming more essential to our survival and evolution. Museums dedicated to nature and science play a key role in expanding our understanding of these complex systems.

The new Perot Museum of Nature & Science in Victory Park will create a distinct identity for the Museum, enhance the institution's prominence in Dallas and enrich the city's evolving cultural fabric. Designed to engage a broad audience, invigorate young minds, and inspire wonder and curiosity in the daily lives of its visitors, the Museum will cultivate a memorable experience that will persist in the minds of its visitors and that will ultimately broaden individuals' and society's understanding of nature and science.

High performance design and incorporation of state of the art technologies will yield a new building that will minimize its impact on the environment.

This world class facility will inspire awareness of science through an immersive and interactive environment that actively engages visitors. Rejecting the notion of museum architecture as neutral background for exhibits, the new building itself becomes an active tool for science education. By integrating architecture, nature, and technology, the building demonstrates scientific principles and stimulates curiosity in our natural surroundings.

The immersive experience of nature within the city begins with the visitor's approach to the museum, which leads through two native Texas ecologies: a forest of large native canopy trees and a terrace of native desert xeriscaping. The xeriscaped terrace gently slopes up to connect with the museum's iconic stone roof. The overall building mass is conceived as a large cube floating over the site's landscaped plinth. An acre of undulating roofscape comprised of rock and native drought-resistant grasses reflects Dallas's indigenous geology and demonstrates a living system that will evolve naturally over time.

The intersection of these two ecologies defines the main entry plaza, a gathering and event area for visitors and an outdoor public space for the city of Dallas. From the plaza, the landscaped roof lifts up to draw visitors through a compressed space into the more expansive entry lobby. The topography of the lobby's undulating ceiling reflects the dynamism of the exterior landscape surface, blurring the distinction between inside and outside, and connecting the natural with the manmade.

Moving from the compressed space of the entry, a visitor's gaze is drawn upward through the soaring open volume of the sky-lit atrium, the building's primary light-filled circulation space, which houses the building's stairs, escalators and elevators. From the ground floor, a series of escalators bring patrons though the atrium to the uppermost level of the museum. Patrons arrive at a fully glazed balcony high above the city, with a bird's eye view of downtown Dallas. From this sky balcony, visitors proceed downward through the galleries. This dynamic spatial procession creates a visceral experience that engages visitors and establishes an immediate connection to the immersive architectural and natural environment of the museum.

The path descending from the top floor through the museum's galleries weaves in and out of the building's main circulation atrium, alternately connecting the visitor with the internal world of the museum and with the external life of the city beyond. The visitor becomes part of the architecture, as the eastern facing corner of the building opens up towards downtown Dallas to reveal the activity within. The museum, is thus, a fundamentally public building—a building that opens up, belongs to and activates the city; ultimately, the public is as integral to the museum as the museum is to the city.

社会的経験や文化的表現を収集しておくための器のような存在として，博物館はこの世界を理解するためにいろいろな方法を提供してくれる。博物館とは知識を収容し，情報を保存し，思想を伝える存在である。また，好奇心を刺激し，世界への意識を高め，知的交流の機会を生み出しているのだ。教育や社会変革のための道具として，博物館には私たち自身と私たちの住んでいる世界への理解を形象化する可能性が秘められている。

私たちを取り巻く地球環境は，かつてないほどに危機的状況に置かれている。そのため，自然界のシステムへの相互依存に対

1 MAIN ENTRY
2 ENTRY PLAZA
3 ROOF DECK
4 LOBBY
5 MUSEUM STORE
6 CAFE
7 KITCHEN
8 THEATER
9 GALLERY
10 AUDITORIUM
11 EDUCATION
12 MECHANICAL
13 ATRIUM
14 OFFICE
15 BUS DROP OFF
16 LOADING DOCK

Level 3

Level 4-1

Level 1

Level 1-1

するより広汎な理解こそが，私たちの生存と発展においてより一層，不可欠なものとなってきている。自然と科学とに捧げられることを旨とする博物館は，これらの複合システムへの理解を深める上で重要な役割を担っている。

ヴィクトリー公園内にある新しいペロー自然科学博物館は，博物館にはっきりしたアイデンティティを与え，ダラスにおける自然科学博物館の重要性を高めるとともに，この都市の文化的枠組みをより豊かなものにするだろう。幅広い観衆を魅了し，子供達の気持ちをわくわくさせ，来館者の日常生活にある驚嘆や好奇心を刺激するように計画されている。そのため，ここでの印象的な体験は来館者の心に永く留まり，ついには個人および社会の自然や科学に対する理解をより一層深めるのである。

この博物館は，この種類の建築にとって最高水準のサステナビリティを達成するように計画されている。品質の高いデザインと最新技術の導入によって，環境への負荷を最小限に抑えた新しい建築がもたらされるようになるだろう。

世界でも一流の施設として，来館者を積極的に惹きつけ，夢中にさせるインタラクティブな環境が，科学に対する意識を刺激するようになっている。博物館建築とは展示のための中立的背景である，という既成概念を拒否することによって，この新しい建築はそれ自身で，科学教育のために積極的な役割を果たしている。ここでは科学的原理を分かりやすく説明し，私たちをとりまく自然に対する好奇心がかき立てられるように，建築，自然，技術とが一つに統合されているのである。

博物館にやってくる来館者は，テキサスに固有の二つの生態環境を通じて，町中でも自然を心ゆくまで体験することができる。すなわち，天蓋のようにひろがる巨大な自然林と，原生する砂漠植物のゼリスケープ（水資源保護を目的としたランドスケープ手法）によるテラスとである。ゼリスケープ・テラスは緩やかにスロープを描き，博物館を象徴する石貼りの屋根へと連続している。この建築のマッスは全体的に見て，ランドスケープ化された基壇から浮き上がる巨大な立方体として計画された。1エーカーに及ぶ，うねるようなルーフスケープは岩石と乾燥に強い原生の芝草で構成されている。このルーフスケープはダラス固有の地質学的特徴を反映するとともに，生態環境が時間をかけて自然に進化する様を再現している。

この二つの生態環境の相互作用がメインエントランス・プラザの特徴となっている。プラザは来館者のためのイベント・エリアであるとともに，屋外のパブリックスペースとしてダラス市民に開放されている。プラザからはランドスケープ・ルーフが立ち上がり，閉鎖的な空間から大きく開放的なエントランス・ロビーへと来館者を導き入れるようになっている。ロビーのうねるような天井のトポグラフィーは外部のランドスケープ化された表層のダイナミズムを反映し，内外部の境界を曖昧にするとともに自然と人工とを結びつけている。

閉鎖的なエントランスから中に入ると，遥かに開放された天窓のあるアトリウムのヴォリュームを通して，来館者の視線は上に向けられるようになっている。この光溢れるアトリウムには，階段，エスカレータ，エレベータといった建築の主要動線が内包されている。利用者はまず地上階から一連のエスカレータでアトリウムを抜けて，博物館の最上階に到着する。周りの町並みよりもはるかに高い全面ガラス貼りのバルコニーからは，ダラスのダウンタウンを一望に見渡すことができる。このスカイ・バルコニーからは，時計回りにギャラリーを見ながら螺旋状の通路で降りてくることができる。このダイナミックな空間が生み出す感動的な体験は来館者を惹き付けるとともに，博物館の建築と自然とを一つの環境へ緊密に結びつけている。

博物館の最上階からギャラリーを通り抜けるように降りてくる通路は，建築の主要動線であるアトリウムの内外を縫うように進みながら，来館者と博物館内部の世界やその外部に広がる活気ある町並みとを交互に結びつけている。建築の東側のコーナーは内部の活動が外からも分かるようダラスのダウンタウンに対して開放されている。外から見ると，中にいる来館者は建築の一部であるかのようだ。それゆえこの建築は，開放され，この町に対して活気を与えているという点において，本質的には公共建築である。公共性が博物館にとって不可欠な要素であるのと同様，この博物館もまた，この町にとってなくてはならない存在なのである。

Unfolded precast elevation

Sections

Top of atrium

90

SERVICE
MECHANICAL/PENTHOUSE
BUILDING CORE
BACK OF HOUSE

OFFICE
OPEN OFFICE

GALLERY
ANIMALS THROUGH TIME / UNIVERSE GALLERY
ENERGY / GEM / EARTH GALLERY
ENGINEERING / BEING HUMAN / LIFE GALLERY
SPORTS GALLERY
TEMPORARY GALLERY
CHILDREN'S MUSEUM

CAFE/ SHOP
MUSEUM SHOP
CAFE

EDUCATION
CLASSROOMS
FORUM

LOBBY
MAIN LOBBY
ROOF TERRACE
ENTRY LOBBY

THEATER

Program

Escalator

© Michael Powers (✱)

✱

91

Diagram: global systems organization (2D)

Diagram: global systems organization (3D)

Exploded axonometric: building composition

92

Construction document: precast panel facade elevation

Construction document: precast panel layout

Construction document: precast atriums

Emerson College Los Angeles Center

2008-12 Los Angeles, California, U.S.A.

North view

Site plan

Diagram

Emerson College, located in Boston, Massachusetts, has maintained an internship program in Burbank, California for approximately 20 years. The new Emerson Los Angeles Center, located on Sunset Boulevard amidst the studios of Hollywood, provides a permanent location for the program, both for its instructional/administrative facilities and its residential student housing. In so doing, the College seeks to enhance its presence and identity within a city that is not only the center of the television and film industry but is home to many of its alumni.

The site for the Emerson College Los Angeles Center is located at the intersection of Sunset Boulevard and Gordon Street in Hollywood, California. The area provides the perfect context for the Emerson internship program that seeks to link its rising, graduating talent with the Entertainment Industry here in Los Angeles. A neighborhood on the rise, the new site offers views to the north of the Hollywood Hills and the "HOLLYWOOD" sign; to the south a view over the trees of the Hollywood Forever Cemetery, a center for community events and Hollywood movie nights; to the east the Hollywood freeway and the newly built Helen Bernstein High School, a trade school to the media arts; and to the west the vast array of studio buildings and live/work lofts, and of course, if on a very clear day, the Pacific Ocean.

The Emerson College Los Angeles Center responds to its setting; as a pearl inside its shell, the sculptural form of the cube counters the discord of Sunset Boulevard. Nestled within the outermost layer of residential program, the academic program is revealed and its architecture expressed, creating a new institutional model of what has become the more well-known live/work environment in Hollywood. Driven by the site's small footprint, the integration of programs into a single building produces a vibrant and synergetic atmosphere that fosters social interaction and cross-pollination of the College's departments.

Creating a semitransparent backdrop, the geode is lined with a textured scrim. Draped from the two bars of residential program flanking the academic form, the scrim serves not only as the guardrail for the exterior balconies, but also the facades for the outdoor "rooms"—the academic terrace on the second floor and the residential terrace and grand stair on the fifth.

Aiming for a minimum LEED-Silver rating, the Emerson College LA Center takes advantage of the temperate climate of Los Angeles to minimize energy and water use. The project delivers advanced green building initiatives including radiant heating and cooling, operable sunshades, and a stormwater filtration system that removes impurities onsite before returning water to the city sewer system.

The project provides outdoor terraces and instructional spaces which can be used by staff, faculty, students and college guests. In addition to 16,000 sq.ft. of outdoor space, Emerson College LA Center encompasses 23,000 sq.ft. of instructional and administrative program, 78,000 sq.ft. of student housing as well as faculty and staff apartments, 6,000 sq.ft. of retail space, and 120,000 sq.ft. of parking. The retail space, is located along Sunset Boulevard.

Street view

Second floor

Fifth floor

Eighth floor

1. STAIRCASE TO MAIN ENTRANCE
2. RETAIL
3. PARKING
4. TERRACE
5. LOBBY
6. FOCUS GROUP/ OBSERVATION
7. ACADEMIC
8. CASE STUDY
9. EXTERNAL STAIRCASE
10. SCREENING ROOM
11. PERFORMANCE STUDIO
12. MEETING ROOM
13. ATRIUM
14. RESIDENTIAL

First floor

Third floor

Seventh floor

Section 01

Section 02

Section 03

Academic building △▽

97

Interior skin: panel types

Interior skin east panels

Interior skin panel diagram: rotation

マサチューセッツ州，ボストンにあるエマーソン・カレッジは，約20年にわたりカリフォルニア州のバーバンクにおいてインターンシップ・プログラムを継続してきた。サンセット大通りのハリウッドスタジオ群の只中に位置するこの新しいエマーソン大学ロサンジェルス・センターは，このプログラムを常設するために必要な教育及び運営の施設と，学生のための居住スペースの両方を提供する。これにより，テレビや映画産業の中心であるだけでなく，将来この大学の卒業生にとって本拠地となるこの街で，大学はその存在感と独自性を高めていくことを目指している。

エマーソン大学ロサンジェルス・センターの敷地はカリフォルニア州ハリウッドのサンセット大通りとゴードン・ストリートの交差点脇にある。このエリアは，プログラムを通じて成長し卒業していく才能を，ロサンジェルスのこの地に展開する娯楽産業へ結び付けたいと考えるエマーソン・インターンシップ・プログラムにとって申し分無い環境を提供している。発展する近隣地域の中で，この新しい敷地では，北側にハリウッド・ヒルとあの「HOLLYWOOD」の看板が見える。南側は，地域コミュニティやハリウッド映画の夕べなどのイベントが行われる中心地であるハリウッド・フォーエバー墓地の木々が見渡せる。東側は，ハリウッド高速道路や新しく建設されたメディアアート主体の職業訓練校であるヘレン・バーンスタイン高校がある。西側は，広大なスタジオ建築の並びと住居・職場のためのロフト群があり，当然のように，よく晴れた日には太平洋が見渡せる。

エマーソン大学ロサンジェルス・センターはこうした環境に対応している——貝殻の中の真珠であるかのように彫塑的な形態を内包する立方体が，サンセット大通りの不協和音とは逆の姿として対置されている。立方体の最外周部に配置された学生寮区画の中に埋め込まれた教育区画は，居住兼仕事というスタイルが提供された環境として知られるようになったハリウッドの中に新しい社会施設環境のモデルを創造するべく，建築的に表現され，その姿が示されている。与えられた敷地の小

Interior skin west panels

Interior skin west panels type

Atrium

ささに触発されて考案された，様々なプログラムを一つの建物内に統合するこのプロジェクトのコンセプトは，大学の各学部の間で社交的な交流や，こうした交流を通じた「他花受粉」による成果の結実を促進し，活動的で相互作用を生み出していくような雰囲気を作り出している。

半透明の背景をつくり出すように，建物の内側のファサードは，パターンを持った紗幕で覆われている。教育区画の側面にある板状の二つの学生寮区画がまとうこの紗幕は，外部バルコニーの手摺りとして機能するだけでなく，外部に並ぶ「部屋」の連なり——教育区画の2階にあるテラスや，5階部分にある寮のテラスや大階段——のファサードとしての役割も果たす。

環境性能評価システム（LEED）によるシルバー認定を満たすことを目標に，エマーソン大学ロサンジェルス・センターはロサンジェルスの持つ温暖な気候という利点を用いながら，電力と水利用を最低限に抑えている。高度に環境配慮された建物を提案する取り組みとして，このプロジェクトには放射熱冷暖房，可動式日除け，さらには雨水の不純物を建物で濾過してから市の下水システムに戻す雨水浄化システムなどが盛り込まれている。

このプロジェクトでは大学スタッフや教員，生徒，さらに大学へのゲストが利用出来る外部テラスや教育スペースが提供されている。16,000平方フィートもの屋外空間に加え，23,000平方フィートの教育及び運営プログラムが内包され，さらに78,000平方フィートの学生寮空間や教員や大学スタッフの共同住宅，6,000平方フィートの店舗スペース，そして120,000平方フィートの駐車スペースが提供される。なお店舗スペースはサンセット大通り沿いに位置している。

King Abdullah Petroleum Studies and Research Center

2008–09 Riyadh, Saudi Arabia

The new King Abdullah Petroleum Studies and Research Center (KAPSARC) is a tangible symbol of environmental innovation. Our proposal redefines the traditional campus into a three dimensional master plan of interconnected built form and planted landscapes that accommodate discrete zones of public and private program while also creating intersection and overlap between the two. Embedded in this sculpted environment, an iconic hybrid building emerges amidst a protected oasis of native desert flora and naturally cooling reflecting pools. Our strategy grows out of the same environmental forces that have shaped desert cultures and plant species in the region over the course of history.

Traditionally, walled oasis villages (such as the old city of Dir'iyah, the ancestral home of the Al-Sauds and the birthplace of the Saudi-Wahhabi union) have incubated the expansion of culture in the region. The new KAPSARC master plan is rooted in the historical model of the oasis village: pools of recycled water naturally cool the air and create a habitable climate; gardens of endangered desert plants surround and weave between the architecture; and the iconic research center building rises at the core of the site, with walls radiating out to offer both symbolic and literal protection. As if generated by the dynamism of the research nucleus, the security walls and glowing light bars emanate from the Center—building becomes wall, which in turn activates and organizes the site.

Parallel to cultural responses to the environment, which have yielded typologies like the walled oasis village, desert plants around the world have evolved optimal forms to thrive in extreme climates. For example, the cactus, a typical desert ecosystem plant native to the Americas, has developed a maximum volume with minimal surface area, to mitigate the plant's exposure to the elements and protect its precious supply of water. Inspired by the cactus's compact, efficient form, our proposal concentrates the public and research program areas into a single, hybrid building, to afford the Center and its users a space that offers both comfortable respite from the desert, and social, cultural, and intellectual intensity.

KAPSARC's core intellectual mission—research on energy and the environment—forms the iconic heart, or nucleus, around which all of the Center's public and private programs converge. The nucleus takes architectural form as an ovoid that emerges from the sculpted landscape, with all other program and site elements radiating out from this core. The ovoid's iconographic power palpably conveys KAPSARC's identity to the outside world; simultaneously, the Research center serves as the intensified hub for the inner life of the complex.

The icon also serves as a connector; its striated lattice formally connects with the key public spaces, and its built form is embedded in and interwoven with the structure of the campus. Most importantly, it provides an environment that fosters interaction between researchers to inspire inquiry and stimulate innovation at the highest level, while engaging visitors with the intellectual heart of the campus.

These primary strategies are integrated in an innovative vision that broadens global awareness of KAPSARC as a world-class, independent energy research organization and advances Saudi Arabia's pivotal leadership role as an environmentally responsible energy supplier.

新しいアブドラ王石油調査研究センター（KAPSARC）は，環境問題に対する革新を力強く象徴する。公共的，私的なプログラムを個別の区画に収容し，同時にこれらが交差し，重なり合うように，私たちは従来のキャンパスを相互に連結された建築形態と，植栽の施されたランドスケープとによる三次元のマスタープランへと再定義するように提案した。このような彫塑的環境に埋め込まれた複合建築のアイコンが，砂漠に原生する植物と自然冷却用のリフレクティング・プールのオアシスの直中に現れる。私たちの方法論は，歴史の流れを通してこの地域の砂漠文化や植物種を形成してきたのと同じ環境的影響力から発展してきたものである。

伝統的に，（サウード王家の先祖の地であり，サウード＝ワッハーブ王国発祥の地であるディライーヤ旧市街のような）城壁で囲まれたオアシスの村落は，地域文化の発展を育んできた。新しいKAPSARCのマスタープランはオアシスの村落の史的モデルに根差したものである。すなわち，再利用水のプールは空気を自然に冷却し，居住に適した気候をつくり出す。絶滅の危惧される砂漠植物の庭園は，建築を取り囲み，その間を縫うように進む。そして研究センターの建築はアイコンのように敷地の一角から立ち上がり，放射状に広がる外壁は，象徴的かつ字義通りにこの場所を保護している。あたかも研究の核にあるダイナミズムが生み出すかのようなセキュリティ・ウォールと光輝く照明の束が，中心部から広がってゆく——城壁としての建築が，敷地を組織化し，生を与えているのだ。

城壁で囲まれたオアシスの村落といったタイポロジーを生み出してきた環境への文化的応答と平行して，世界中の砂漠植物は，極限の気候で繁茂するのに最適の形へと進化してきた。例えばアメリカ大陸に原生する，砂漠の生態系にとって典型的な植物であるサボテンは，悪天候への暴露を抑え，貴重な水の供給を保護するために，最小限の表面積で容積を最大化するように発達してきた。サボテンの効率よく引き締まった形態に着想を得ることで，私たちは公共的，私的なプログラムエリアを単一の複合建築へと凝縮することを提案した。このことがセンターとその利用者に，砂漠の世界からの快適な休息と，社会的，文化的，および知的強度とを兼ね備えた空間をもたらしている。

KAPSARCの核となる知的ミッション——エネルギーと環境に関する研究——が，建築を象徴する中心的存在，あるいは核，となる。その周りには，センターのあらゆる公共的，私的プログラムが集約される。核となるのは彫塑的ランドスケープから現れる卵状の建築的形態である。そしてこの中心から他の全てのプログラムや敷地を構成する要素が放射されるのだ。卵の形状の持つ図象学的な力は，KAPSARCの本質を外部の世界に明確に伝えている。また，同時に研究センターが，複合体の内部活動を強化するハブの役割を果たしている。

アイコンにはまた，コネクターとしての役割がある。線状格子が主要パブリックスペース同士を形態的に結びつけるとともに，その構造形態はキャンパス構造へと埋め込まれ，編み込まれるのだ。最も重要なのは，探究心を奮い立たせ，革新を刺激する研究者同士の最高水準の交流を促し，その一方で来館者をキャンパスの知的活動の中心へと惹き付ける環境を提供することである。

これらの主要な方法論は，KAPSARCが世界レベルの独立したエネルギー研究機関であることを世界が広く認め，サウジアラビアが環境に責任あるエネルギー供給国として重要な指導的役割を推進するための革新的ビジョンへと統合される。

© Michael Powers

View from south

North view

Campus Organization: creating a site-specific typology

Landscape: using built form to carve out site conditions

103

1 LIBRARY
2 LIBRARY SUPPORT
3 RESEARCH
4 RESEARCH SUPPORT
5 INTERACTION ZONE
6 PASSIVELY COOLED OUTDOOR AREA
7 BUILDING SERVICES
8 CONFERENCE CENTER

Sections

0 20 50 100 ft

Exploreded axonometric

104

Atrium

Structure diagram: Research Tower

tension wire · truss ring
tension
compression
ring beam, floor slab
column
structural load diagram

Models: Research Tower

Structural components: Research Tower

shell structure of conference space
- column
- ring beam
- bracing

interior suspending structure
- truss ring
- ring beam
- tension wire

structure of exterior shell
- primary column
- secondary column
- ring beam
- bracing

concrete structure of core
- concrete core

Level 08

Level 09

1	EXHIBIT SPACE
2	GENERAL COLLECTION
3	LIBRARY
4	PLACE OF GATHERING
5	VISIT CENTER
6	AMENITIES LOUNGE CAFE
7	RESOURCES DEVELOPMENT CENTER
8	SPECIFIC PROGRAM
9	REFERENCE AREA
10	DEPOSIT COLLECTION / GENERAL INFORMATION
11	MEDIA COMMONS
12	LEARNING COMMONS
13	CENTRAL REPROGRAPHICS PRINT AND COPY SHOP
14	INFORMATION CENTER
15	PLACE OF INTELLECT
16	SEMINAR ROOMS
17	STAGING KITCHEN
18	CONFERENCE
19	MULTI-PURPOSE ROOM
20	SERVERY
21	DINING AREA
22	EXERCISE
23	RESEARCH CENTER ENTRY
24	RESEARCH CENTER DROP-OFF
25	RESEARCH ADMINISTRATION
26	RESEARCH
27	ROOF TERRACE
28	PRESIDENTIAL OFFICES
29	BOARD ROOM
30	CONFERENCE ROOM

Level 05

Level 06

Level 02

Level 04

Level 00

Level 01

Four Towers in One Competition

2008 Shenzhen, China

Shenzhen, Southern China's major financial center and among the fastest growing cities in China for the past thirty years, exemplifies the contemporary global city. Movement-, communication- and transaction-based, Shenzhen's new financial district is fundamentally a space of exchange, a "networked, a-historical space of flows." Interconnected systems of exchange permeate not only Shenzhen's international commerce, but also the city's civic life and the interactions between individual citizens and workers. Our nuanced, three-dimensional urban design integrates core values of sustainability and connectivity into an innovative vision for a 21st century master plan. The resultant architecture reflects a global significance and local specificity to Shenzhen, the site, and each client.

Broadly understood, three primary principles drive the 4 Towers in 1 project:

An Interconnected, Three-Dimensional Master Plan

In response to the interconnectedness of the new global city, our scheme re-conceives the conventional urban grid as a dynamic, multi-dimensional organization, or armature, able to support the complex systems that define contemporary urban life. Like the complex yet coherent intricacy of a traditional Chinese puzzle, each site is conceived as a 3-dimensional envelope, interwoven with the other projects, rather than as a 2-dimensional isolated footprint. The well-established strategy of transferring air rights allows the zoning envelope for each building site to evolve beyond a simple vertical extrusion of the site's footprint, to facilitate a network of interlocking forms reminiscent of the venerated Chinese puzzle.

Re-conceiving the Icon of the Tower to Create a Distinctive Financial District

Our scheme questions the appropriateness of creating a field of disassociated vertical skyscrapers on the site, in favor of creating a cohesive, interwoven district. The tower—conventionally thought of as an isolated, autonomous object—is now rooted in a new urban fabric, interwoven with fluid built forms and vibrant civic spaces. Rather than considering each individual tower as its own discrete icon, our scheme conceives the entire Financial District as a new type of icon—a district with its own unique character amidst the greater city of Shenzhen—that will attain world-wide recognition.

Forging a Synergistic Collaboration Between the Public and the Private Sector

Extending the primary metaphor of the Chinese puzzle, each individual project maintains its distinct form and identity while integrating with the other elements of the project. The result is a holistic scheme that is greater than the sum of its parts—where integration and collaboration create enormous pragmatic and symbolic potential for all stakeholders. This scheme creates a scenario that is beneficial for both the public sector and each private institution: an enduring vision for the city, which both expresses public purpose and intentionality and amplifies the identity of the individual projects and the institutions they represent.

West building

© *Michael Powers*

Site plan

1 WEST BUILDING
2 EAST BUILDING

OFFICE SPACE
- building A
- building B
- building C
- building D
- building F

GROUND FLOOR PROGRAM
- lobby/atrium
- food services
- retail
- multiple use halls

PEDESTRIAN CIRCULATION
- primary entrance point
- sky lobby
- upper bank elevator
- middle bank elevator
- lower bank elevator
- freight elevator
- hardscape
- green space
- building footprint
- bicycle paths

INFRASTRUCTURE
- roads
- subterranean parking
- metro stop
- metro parking
- vehicular movement
- parking entrance

COMPOSITE

CONCRETE CORES FLOOR PLATES DIAGRID/COLUMNS

Structural diagram: West building (above) and East building (below)

Diagram

108

West building

Lower levels

中国南部の金融の中心地である深圳市は，過去30年間，中国で最も速いスピードで成長してきた都市のなかでも，現代の世界都市を代表している。トレンド，情報，経済活動をベースとした深圳市の新しい金融都市の本質は，交換取引のための空間，すなわち「組織化され，歴史なき，流れゆく空間」である。相互連結された交換システムは，深圳市の国際貿易のみならず，この都市の市民生活や，市民と労働者の個々の交流といったところにまで浸透している。私たちの繊細な，三次元的な都市計画は，21世紀の全体計画に向けた革新的ヴィジョンに向けて，持続性や連続性といった中心的価値を統合するものである。その結果生まれた建築は，深圳市や敷地，各々のクライアントの国際的重要性と地域的特殊性とを反映したものである。

広義には4タワーズ・イン1の計画を構成するのは次の三つの主要原則である。
〈相互連結された三次元マスタープラン〉
新しい国際都市の相互接続性への応答として，私たちの計画では通常の都市グリッドを，現代の都市生活を特徴づける複合システムに対応可能な動的かつ多元的な組織，あるいは骨格として新たに構想している。しっかりと組み合った中国の複雑で伝統的なパズルのように，各々の敷地は個々に隔離された平面的な建築占有面積としてではなく，別の計画へと編み込まれる三次元のエンベロープと見なされた。空中権譲渡のため確立された方法論は，敷地の建築占有面積を単純に垂直方向に押し出すということ以上のものへと各々の敷地のゾーニング・エンベロープを導くことを可能にし，優れた中国式パズルを連想させる相互に連結された形態の組織化を促している。

〈独自の金融都市を生み出すタワー建築の象徴性に関する再検討〉
私たちの考えでは，敷地一面に，自己完結した垂直のスカイスクレーパーをつくることの妥当性について懐疑的であった。複雑に絡み合いひとつにまとまった区画をつくりだすことが望ましい。タワー建築——通常の考えでは孤立して自律的なオブジェクト——は最早，新しい都市構造に根差し，流体的な形態と活気ある都市空間に編み込まれる。各々のタワー建築自身の個別の象徴性について検討するよりも，私たちの計画では金融街全体を——深圳という大都市の直中で独特の性格を持つ街区として——世界的な認識に到達しうるような新しい種類の象徴として考えている。

〈公共部門と民間部門の相乗的協力関係の構築〉
中国式パズルという当初のメタファーから敷衍されるのは，計画上，他の要素へと統合されながらも，固有の形態と独自性を保持し続ける各々個別の計画である。その結果，全体構想は部分の総和よりも一層卓抜したものとなる——ここでは統合と協同とが，全ての利害関係者に対する膨大な実務的かつ象徴的潜在可能性を生み出すのだ。この構想が生み出すのは公共部門とそれぞれの民間団体の双方に利益をもたらすシナリオである。すなわちそのような都市の永続的ヴィジョンが，公共の目的やその意図を表明するとともに，個別の計画とそれらの計画によって表象される組織の独自性を一層高めているのだ。

East building: fourth floor (left) and 17th floor (right)

West building: fourth floor

1 RECEPTION
2 MEETING SPACE
3 GREEN SPACE
4 OFFICE SPACE

East building

1 HELIPAD
2 MECHANICAL FLOOR
3 SKY GARDEN
4 DOUBLE HEIGHT MEETING SPACE
5 PARKING
6 ATRIUM

East building: section

West building: section

111

West building

New U.S. Embassy in London

2009–10 London, U.K.

Site

Site plan

Concept diagram

Analysis: dome and atrium

Figure of skin

Entrance plaza

© Michael Powers

Consular lobby

Bridge at atrium

116

Diagram: dome design and atrium

Embassy architecture serves as a powerful symbol that provides an instantaneous and indelible impression of a country. Public buildings project the identity of a country's peoples, culture and aspirations. American public buildings convey the collective identity of our rich, culturally diverse, and increasingly complex society. An American embassy's design expresses to the world the ideals of American democracy—the optimism, hope and promise of our time. By communicating the transcendent values that define the United States as a nation, the new Embassy of the United States of America in London has the potential to embody a new age of American openness, transparency, and renewed commitment to international collaboration. A U.S. Embassy also acts as a symbolic gateway between two countries.

Architecture itself becomes an act of public diplomacy; as the United States Department of State envisions, the design of the new Embassy "far transcends architecture and engineering… it is fully and firmly within the realm of international diplomacy." The new U.S. Embassy in London is a tangible expression of our country's singular, deep connection with the United Kingdom. Our two countries share an intellectual heritage and common legal foundation that dates back to the origins of the United States' own foundation, with the Magna Carta's influence on the formation of the American Constitution and Bill of Rights. The "special relationship" that developed between our two countries over the course of the past century's geo-political events endures to this day. The design of the new Embassy embodies the longstanding exchange of culture and ideas between the U.S. and U.K., and ensures that our countries' strong political alliance will continue to thrive into the future. A home away from home for American diplomats and for American citizens residing in the U.K., the Embassy inspires a sense of common purpose, shared identity and civic pride.

Our design for the new U.S. Embassy in London translate these multiple layers of symbolic, historical, contextual and cultural meaning into a legible architectural expression.

An Open, Accessible Site that Stimulates Transformation of its Urban Context

The design of the site champions openness while ensuring security. To create a perception of accessibility and integrate with the immediate context, the site's landscape slopes down to meet the street at ground level. To galvanize regeneration of the surrounding Nine Elms area, the scheme gifts to the city of London two significant public plazas: a public park that links to the river to the north and a Consular Plaza that connects to the proposed pedestrian corridor to the south.

An Iconic Chancery Tower that Embraces London

From the plinth, defined by the earth-sheltered consulate's sloping green roof, rises the honorific chancery tower. The fluid form of the chancery tower establishes an iconic presence on the London skyline. Orientated towards the river and the city, the tower reaches out to embrace the city of London. The tower's wings extend in an expansive gesture towards the city, opening to reveal a translucent dome at the heart of the building.

A Central Translucent Dome as a Universal Symbol of Democratic Ideals

Our proposal translates the universal symbol of the dome into a contemporary expression of the Embassy's public character and America's civic ideals of democracy and freedom. Enveloped in translucent glass, the central soaring domed atrium reaches the full height of the building to function as a connective space at the heart of the Embassy. In the tradition of London's major domed public gathering spaces, the dome marks the Embassy as a civic landmark for the city, born out of the architectural heritage shared by the U.S. and U.K.

As the global political and economic climate is poised at this incredibly dynamic, critical, and complex moment in history, our design seeks to create a new U.S. Embassy that stimulates optimism and the highest aspirations for enhancing a peaceful, civilized society.

大使館の建物は，その国に対する印象を瞬時に，かつ消し去ることのできない形で与える力強い象徴としての役割を果たす。公共建築は一般に，その国の人々のアイデンティティや文化，強い憧れなどを投影している。アメリカの公共建築においては，豊かで，文化的に多様でありながら，より複雑さを増している我々の社会の姿が総合された自己認識としての姿を表している。そしてアメリカ合衆国大使館のデザインは，アメリカの持つ民主主義の理想——最善を尽くす主義，我々が生きる今この時の希望や展望——といったものを世界に向けて表現している。アメリカを国家として特徴づけるその並外れた意味を世界に伝達する上で，このロンドンの新アメリカ大使館は，アメリカの開放性や透明性，そして志も新たな国際間協調に関するアメリカの真摯な取組みといった新しい潮流を体現し得る可能性を持っている。アメリカ大使館はさらに，二つの国の間に通じ合う象徴的な通路としての役割も果たす。

ここでは建築が，開かれた外交機能そのものとなる。アメリカ国務省が描いているのは，新しい大使館の設計が通常の建築や工業技術を超越し，完全に，また確固として国際外交の領域上に存在する姿である。そしてこのロンドンの新アメリカ大使館は，我々の国アメリカとイギリスとの間にある，唯一無二かつ深い関係を明確に表現したものである。我々二ヵ国の間には，アメリカ合衆国憲法や権利章典におけるマグナ・カルタの影響に見られるように，アメリカ合衆国自身が成立した源流まで遡ることのできる知的財産や共通の法的基盤が共有されている。過去百年の歴史の中で起こった地政学的な出来事の数々によって発展してきた，我々二ヵ国間の「特別な関係」は，今日まで持続してきた。新しい大使館の設計がアメリカとイギリスの間で長期にわたり交わされてきた文化や考え方を体現することで，我々二ヵ国間の強固な政治的協調が未来に向けてより強く成長していくことを確かなものにする。そしてアメリカ合衆国外交官の国外の住処として，またイギリスに在住するアメリカ市民のために，この大使館は彼らの共通の目的や共有されたアイデンティティ，アメリカ市民としての誇りの意識といったものを呼び起こす。

ロンドンに位置するこの新しいアメリカ大使館のデザインでは，象徴や歴史，文脈や文化といった，様々な意味合いの重層する様を，建築的表現によって識別可能な要素へと翻訳している。

〈プロジェクト周辺の持つ都市的文脈の変容を刺激し促進する，開放的でアクセスしやすい敷地〉

敷地のデザインは，開放性を擁護しつつ，安全性も確保している。アクセスのしやすさを感じさせながら敷地周辺の文脈と共存させるため，敷地のランドスケープ部分は地上階で道路につながるよう傾斜したものとなっている。ナイン・エルムス地区の再生を刺激していくために，この案ではロンドン市のために二つの大きな広場を提供している：敷地北で河へとつながる公共公園と，敷地南に計画されている歩行者用回廊へとつながる「領事広場」である。

〈ロンドンの街を抱くアイコニックな大使館タワー〉

緑で覆われ，地面と一体化した領事部の入る台座から，ロンドンに敬意を表す大使館のタワーが立ち上がる。大使館のタワーの流動的な形態は，ロンドンのスカイラインの輪郭にアイコニックな存在感を確立する。河と街に向けて位置付けられたこのタワーは，ロンドンの街を受け入れるように伸び上がる。タワーの両翼は街に向かって広がっていくかのように張り出し，建物の中心部を成す半透明のドームの存在を現わしながら開いていく。

〈民主主義の理想の普遍的な象徴としての半透明中央ドーム〉

我々の提案では，ドームの持つ普遍的な象徴性を，大使館の公共的な性格と，アメリカの民主主義と自由に対する市民の理想の現代的表現として転化している。半透明のガラスで覆われて空高くそびえる中央ドームの吹き抜けは，建物の最頂部近くにまで達しており，大使館の心臓部に位置する接続空間として機能する。アメリカとイギリスの間で共有されてきた建築遺産の中から生まれたこのドームも，ロンドンにある他の主要なドーム状の人の集まる公共スペースの伝統に倣い，大使館を街の市民ランドマークとして印象づける役割を果たしている。

この非常にダイナミックで重大な，かつ複雑な歴史上の瞬間において，世界的な政治経済の傾向は制止状態にあるが，物事において最善を尽くすという我々の主義を力づけ，平和で文明的な社会を高揚していくための最大限の目標となるような新しいアメリカ大使館の創造を，設計に際して我々は目指している。

Taipei Pop Music Center

2009 Taipei, Taiwan, R.O.C.

Aerial view

Component diagram

Auditorium: location study

Site plan

View from northeast

Street view

119

Site diagram

Popular music absorbs and transmits ideas through everyday life, influencing lifestyles, fashion, attitudes and language. Its specificity is highly unique in relation to other musical forms; pop music is commercial, ephemeral and accessible, relying on technological innovations and broad public appeal. The Taipei Pop Music Center presents an extraordinary opportunity for architecture—as a means through which ideas of popular music are disseminated. Its potential is endless for the City of Taipei—as a vibrant, global center for musical creativity. For the urban fabric of Nangang, the project presents infinite possibilities for transforming its industrial past into a vibrant round-the-clock cultural district.

The Taipei Pop Music Center is expansive in its global impact, yet grounded in its local context and musical form. It assumes the transient quality of popular music; accommodating rapid changes in trends and technology, engaging day to day sensibilities rather than reflecting an iconic image. When the British youth culture invaded the American rock & roll industry, first in the 1960s with Beatlemania, and second in the 1980s with music videos, the collision transformed American music and established the British record industry as a vital center for musical creativity. Our design for the Taipei Pop Music Center aims to inspire this calibre of phenomenon by creating an exciting venue for interaction and collaboration—an environment that facilitates the continuum of cultural regeneration, which is vital to Taiwanese pop culture and essential to its musical form.

In the spirit of Taiwan's vibrant popular culture and Nangang District's emergence as a center for commerce and creativity, our design for the Taipei Pop Music Center embodies three primary principles and objectives: First, the building's position above the streetscape enriches rather than interrupts the urban life of Taipei. Second, rather than distributing program across the site, the scheme deliberately densifies programmatic functions by creating a compact building environment that generates social and cultural activity through programmatic connections. Third, the flexibility and accessibility of the Taipei Pop Music Center epitomizes the broad public appeal of the popular music and entertainment industries. These three objectives are interrelated and realized in a design that achieves a complete integration of architecture, urban design, program and context all woven into a seamless venue that captures the power of live performance.

West elevation

North elevation

East elevation

South elevation

0 10 25 50 ft

Optimized Organization

The accessibility of the Taipei Pop Music Center broadens its public appeal—like pop music, its organization, form and meaning are intended to be broadly understood. Circulation patterns ensure a continuous flow of movement while the efficient programmatic configurations create an exciting environment in which the activity of each program is reinforced by the magnetic energy of the main space. From the building's main entry, the spectators emerge onto the building's primary lobby space—moving into the indoor and outdoor theaters, circulating upward into the livehouses or ascending to the office area or Hall of Fame—this nexus of programmatic functions creates a vibrant corridor that offers a variety of public and retail amenities.

The Performance Space

The dynamic relationship between the indoor and outdoor theaters creates programmatic connections and transparencies of functions that intensify the user experience. The architectural challenge of the two theaters—appropriating space, given the site restrictions as well as capacity requirements for both audiences—creates an enormous opportunity for the design of the Taipei Pop Music Center. Our scheme's innovative stacking solution layers the indoor and outdoor theaters, eliminating redundancy and intensifying programmatic and interactive possibilities.

Moving from the lobby to the indoor main hall, spectators enter the theater at the mezzanine level or descend toward the main stage. The efficiency of the cruciform theater is complemented by its flexibility—the auditorium adapts to the performance, converting the formal seating arrangement into a standing and dancing arena. The atmosphere of the theater completely transforms by utilizing removable seat wagons and storage submerged beneath the level of the main stage.

From the shared lobby space, spectators move into the outdoor theater located toward the southern section of the site, ascending to their seating. A retractable roof structure accommodates various forms of entertainment as well as climate conditions, providing a flexible setting that responds to the needs of specific performances. Taking into account the proximity of the theater to the residential fabric of Nangang, two acoustic strategies contribute to the design of the Taipei Pop Music Center: an innovative roof structure mitigates unwanted sound transmission, and a green wall located at the rear of the seating area diffuses noise from live performances. These two methods of noise prevention produce innovative design solutions that enrich the space while ensuring the comfort and livelihood of the Nangang District.

The Livehouses

Circulating from the lobby space upward and into the livehouses, the spectator enters into the experimental commercial zone—the testing facilities of the Taipei Pop Music Center. The livehouses are primarily for cultivating and internationalizing Taiwan's popular music industry, inspiring a distinct genre of music with influences from Asia, Europe and the United States. The form and configuration of the interwoven livehouses create intimacy and variety, providing an atmosphere for new possibilities of interaction and cultural exchange.

Passing between and through the livehouses, spectators access a series of bridges above the lobby space at the level of the third floor. This pedestrian passage through the lobby space creates a sense of openness that also amplifies the visual experience. Although each livehouse is independent, containing its own interior circulation from the third floor prefunction to the fourth floor main livehouse space, the elevated passage traverses various program zones, creating a sense of connectivity. Breaking through the rectilinear form of the Taipei Pop Music Center, light penetrates through the livehouses, accentuating the atmospheric effects of the venue and underscoring the theatrical setting the live event. On the building's upper floors, along its periphery, the office space of the livehouses support the vitalization of the popular music industry.

The Exhibition Space

Visitors approach the entrance to the Hall of Fame from the southern section of the public lobby. Ascending into the building's third and fourth floors along its periphery, spectators enter the exhibition spaces, which afford magnificent views of the streets of Nangang District as well as interior views that showcase the spectacle of the Taipei Pop Music Center's dynamic lobby space. The Café of the Hall of Fame presents a dramatic setting—bridging over the highly trafficked Xinsheng Road, the cafe provides expansive views of the streetscape that enrich the dining experience.

Live houses: section © *Michael Powers (*)*

Live houses

122

Outdoor auditorium

Outdoor auditorium

Outdoor auditorium: moving canopy and seating

Outdoor auditorium: sound effection

ポップミュージックは，日常生活を通して様々なアイデアを吸収，伝達し，人々のライフスタイルやファッション，振る舞いや言葉遣いに影響を与える。その影響力はその他の音楽と比較しても，非常に際立った特殊なものである。ポップミュージックは，テクノロジーや商業に依拠したもので，短命だが誰もが入手可能な広く開かれたものである。台北ポップ・ミュージックセンターは，ポップミュージックを普及させる手段としての建築であり，活気にあふれた音楽創造のグローバル・センターとして無限の可能性を秘めている。このプロジェクトは，南港の都市部をかつての工業地帯から，昼夜を通して熱気に満ちた文化地域に変えてゆくポテンシャルを持っている。

ミュージックセンターは，ローカルなコンテクストと音楽に依拠しながらも，グローバルな影響力をもっている。流行やテクノロジーの急速な変化を受け入れ，アイコニックなイメージにとらわれることなく日々刻々と変化してゆくポップミュージックの特質に対応している。英国の若者文化がアメリカのロックンロール産業に進出したとき——最初は60年代のビートルマニア，2度目は80年代のミュージックビデオであったが，その衝突はアメリカの音楽を変えると同時に，音楽づくりの場としての英国レコード産業の地位を確立した。我々はこのミュージックセンターをデザインするにあたり，活気にあふれた，ポップカルチャーや音楽に不可欠な文化的再生の連続体を包み込むような環境をつくろうと考えた。

台湾の活気あるポップミュージック文化と商業と創造の中心としての南港を考えるなかで，我々の設計したミュージックセンターは，次の三つの原則と目的を体現している。一つは，通りの上にある建物の存在が台北の都市生活を妨害するのではなく，豊かにすることである。二つ目は，敷地全体にプログラムを分散させるのではなく，プログラム上の関係によって社会的活動を生むようなコンパクトな環境をつくることで，計画的にプログラムの密度を上げることである。三つ目は，施設全体の柔軟性とアクセス性によって，ポップミュージックとエンターテイメントの大きな影響力を表現することである。これら三つの目的は相互に関係し，ライブパフォーマンスの展開するシームレスな場に織り込まれた建築，アーバン・デザイン，プログラム，コンテクストの統合によって実現されている。

効率性を伴う構成

台北ミュージックセンターのアクセスのしやすさは，社会からの注目度を高めてくれる——ポップミュージックのように，このセンターの構成，形態，そして目的を普及してくれるのだ。動線パターンは人々の連続した流れをつくりだす一方で，効率的なプログラムの配置により，個々のプログラムの魅力をさらに強めている。メインエントランスに入った観客は，メインロビーに降り立ち，室内外のシアターに移動した後，上階のライブハウスや下階のオフィスやFameホールへと移動する。これらの機能は，さまざまな公共施設や商業施設のある活気にあふれた道によってつながれている。

〈パフォーマンス・スペース〉

室内シアターと屋外シアターのダイナミックな関係は，プログラムのつながりと機能の透明性を生み出し，利用者に強い空間体験を与える。敷地条件を考慮しながら，二つのシア

First floor

Second floor

1 MAIN STAGE	10 MAIN BUILDING ENTRANCE	19 OUTDOOR AUDITORIUM
2 LOADING	11 BUS DROPOFF	20 AUXILLARY SPACE
3 INDOOR AUDITORIUM	12 TAXI DROPOFF	21 MAIN STAGE
4 PUBLIC SPACE	13 PUBLIC PARKING ENTRANCE	22 HALL OF FAME ENTRANCE
5 PERF.SUPPORT SPACE	14 EMPLOYEE PARKING ENTRANCE	23 PUBLIC ENTRANCE
6 STAGES BELOW	15 CAR PARKING	24 LOADING
7 EMPLOYEE ENTRANCE	16 RETAIL	25 LIVE HOUSE PREFUNCTION
8 MOTORCYCLE PARKING	17 LOBBY SPACE	26 LIVE HOUSE
9 PUBLIC SERVICE PAVILLIONS	18 TICKETING	27 OFFICE
28 HALL OF FAME CAFE	37 RECORDING AND REHEARSAL	
29 HALL OF FAME EXHIBITION	38 MECHANICAL	
30 HALL OF FAME COLLECTION	39 RETRACTABLE ROOF	
31 HALL OF FAME STORE	40 RETRACTABLE ROOF GARAGE	
32 LOBBY BELOW	41 STAGES BELOW	
33 HALL OF FAME DIGITAL LIBRARY	42 INDOOR AUDITORIUM	
34 PUBLIC OFFICE	43 SUBWAY TUNNEL	
35 INDOOR AUDITORIUM TECH SUPPORT		
36 AUDIO VIDEO		

Section

ターの収容人数などの要件をクリアした空間をつくるという課題に対して，我々は二つのシアターのレイヤーを重ね合わせるという手法をとった。無駄な部分を取り除き，プログラムやアクティビティの相互作用を生み出している。

　ロビーから室内のメインホールへ向かうと，メザニン・レベルからシアターに入り，メインステージに降り立つ。十字形のシアターは，フレキシブルな構成をとることで使いやすくなるように，効率的に設計した。オーディトリアムは，フォーマルな着席形式からスタンディングやダンスまで様々なパフォーマンスに対応可能である。メインステージ下部に収納される移動式シート・ワゴンやストレージを活用するなどフレキシブルに使用できる。

　二つのシアター共通のロビーから，敷地南側に位置する屋外シアターへと出る。屋根のストラクチャーは伸縮可能であり，気象条件やさまざまなパフォーマンスに対応したフレキシブルな構成をとっている。シアターが南港の住宅地域に隣接していることを考慮し，二つの音響的対策をとった。不要な音伝達を防ぐ屋根構造と，座席後方にあるノイズ除去のグリーン・ウォールである。これらの防音装置により，地域の快適な生活を守りながら，豊かな空間をつくり出している。

〈ライブハウス〉
ロビーから上部のライブハウスに向かうと，この施設における実験的試みであるコマーシャル・ゾーンに入る。ライブハウスは，台湾のポップミュージックの発展と国際化のための重要な施設であり，アジアやヨーロッパ，アメリカなど全世界の音楽と出会う場でもある。ライブハウスの形態や構成は，文化の相互交流の新たな可能性を感じさせるような親密さと多様性を形成している。

　ライブハウスの間を通ると，3階にあるロビー上方のブリッジに至る。ロビーの歩行者路は開放感にあふれ，視覚的に強い印象を与える。それぞれのライブハウスは，3階から4階へと続く内部動線を兼ねており，互いに独立しているが，上部に持ち上げられたブリッジは，多種多様なプログラムを横断し，つながりの感覚を表現している。光が，直線状の建物の中を貫きながらライブハウスへと差し込み，会場の雰囲気とライブイベントの臨場感を高めてくれる。建物上階の外周部に位置するライブハウスのオフィス・スペースは音楽産業の活性化を支えている。

〈展示室〉
パブリック・ロビーの南側からFameホールのエントランスに向かう。建物の外周部に沿って3，4階レベルに上ってゆくと，展示空間にいたる。この空間では，ロビーのダイナミックな光景と南港地域の素晴らしい眺望を楽しむことができる。非常に交通量の多い新生路の上部にブリッジ状に迫り出したFameホールに付属するカフェからは，通りのダイナミックな光景を眺めながら食事を楽しむことができる。

Third floor

Fourth floor

Section

Shanghai Linkong Plot 15 Concept Design

2010 Shanghai, China

Street view

Landscape

Site analysis

Site plan

127

An Iconic Gateway Stimulating a Dynamic Urban Environment

The Linkong SOHO project provides an opportunity to create a dynamic complex that imbues vitality into the Shanghai Hongqiao Linkong Economic Park while providing a vibrant, iconic gateway to the developing business district. Capitalizing on the site's proximity to the Hongqiao International Airport and adjacency to the Outer Ring Road Highway and Beidi Road Highway, our proposal presents a bold new landmark visible to transient passersby on the highways, international visitors arriving at the airport, and users of the surrounding business district and neighboring environs. A series of lively interior courtyards encourage social activity while two strategically located and highly trafficked thoroughfares provide greater accessibility and connectivity between the Linkong SOHO site and the surrounding existing and future developments. Our proposal is organized around two primary formal strategies: from the exterior, a continuous office bar hovers dramatically over an undulating landscape form; from the interior, four unique courtyards are carved out of the landscape to stimulate a constant bustle of social activity. As the first major structure to be erected in the skyline of Linkong economic park, Linkong SOHO will become a gateway and vital urban center for the area, activating and connecting Lot 15 to the surrounding developments.

Our proposal integrates office bar buildings, an undulating green roof landscape mat, grand courtyards, wide streets and narrow thoroughfares, and parking and subterranean support spaces. At a slender 18 meters wide, the office bar buildings, which house both SOHO Office Type 1 and 2 spaces, easily accommodate a double loaded corridor and individual suites of 150 to 300 square meters on either side. The narrow profile of the office bars ensures natural lighting for all suites, rendering each space highly desirable. The green roof mat provides expansive green space for all users. At the East Courtyard, the roof becomes accessible as it lowers to meet the ground plane; it is also accessible from the office bars and from a series of office spaces that are located within the mat structure. Four unique courtyards are carved out of the green roof mat, defining a series of diverse public spaces. In addition to two primary circulation axes, which connect all four courtyards and link the complex with the surrounding economic park, multiple secondary paths provide visitors with alternate routes and help to define economically viable spaces for the project.

Access to the Linkong SOHO complex is provided at both the eastern and southern sides. Each of these entry points opens onto one of the two primary circulation corridors —one located on the East-West axis, and the other on the North-South axis. The East-West corridor connects the exhibition hall on adjacent Lot 16 to the South Courtyard via an elevated walkway over Xie He Road and through the landscaped East Courtyard. From Jinzhong Road, the North-South corridor is accessed through a dramatic entrance that is created by lifting a portion of the mat building 12 meters above grade. This passage leads directly to the South Courtyard at the intersection of both main axes, stimulating increased connectivity and activity among pedestrians. The seven theater enter-

Level 00

Level 01

West elevation

South elevation

tainment complex marks the intersection of these two axes, and serves as the heart of Linkong SOHO, creating a vital link among the four main courtyards.

Four Dynamic Courtyards

Our proposal carves compelling and easily identifiable spaces out of the underside of the undulating green roof mat. The mat building periodically lifts, revealing points of connection between courtyards and creating dramatic, soaring spaces. The mat then descends and transitions to become the ground, offering public access to the landscaped roof and creating intimately scaled spaces. Not only are all four territories unique and grand in scale, but also, each space provides abundant natural daylight and open space for lively activity. At the same time, these spaces cultivate social interaction in the surrounding retail, commercial office, and entertainment areas. In effect, our proposal for the Linkong SOHO complex creates large scale public rooms, providing intimate yet dynamic urban spatial experiences.

Sustainable Strategies

Our proposal integrates a series of holistically considered sustainable strategies and aspires to provide a model for responsible development for years to come. The narrow profile of the buildings allows for ample natural light in the office suites, reducing the need for artificial light, and in turn, reducing energy load. A sophisticated brise-soleil building envelope system reduces the heat load on the façade, further minimizing energy consumption. The expansive green roof provides another important means of energy conservation throughout the complex: its high performance value insulates the spaces below from heat gain and loss, allowing the building to operate with less energy.

Structural System

The structural system for the Linkong SOHO complex will be comprised of steel and concrete. The two basement levels will be constructed in concrete while the above ground mat and bar buildings will be constructed in structural steel. The project is organized around a 9 m x 9 m grid for optimized space planning efficiency and structural performance.

An Integrated Approach

Through thoughtful intervention and creative development, the Linkong SOHO complex will capitalize on this unique opportunity to create an iconic gateway for the Linkong economic park. The complex creates dynamic exterior and interior experiences, and serves as a connective tissue that links together the Hongqiao International Airport, the Outer Ring Road and Beidi Road Highways, and the surrounding business district not only through commerce, but also culture. This increased connectivity and accessibility enables the development of an armature for a rich and inclusive urban experience that provides inhabitants of the city with a diverse mix of natural, commercial and cultural amenities. All of these objectives are incorporated and realized in a design that will achieve a complete integration of program, architecture, urban design, sustainability and context woven into a seamless whole. This integrated approach will establish the Linkong SOHO project as a vital nucleus of rich urban experience and vibrant social activity.

Level 04

Level 07

East elevation

North elevation

Retail area

Housing area

Sections

Courtyard

Entertainment area

〈動的な都市環境を活気づけるアイコニックなエントランス〉
臨空SOHOプロジェクトは，上海虹橋臨空エコノミック・パークに生命力を吹き込む巨大なコンプレックスと，開発の進行する活気溢れたビジネスエリアへと続くアイコニックなゲートをつくる計画である。我々は，上海虹橋国際空港と外環高速，北翟路に隣接する敷地において，高速道路を車で通過する人々や国際空港に到着する人々，周辺のビジネス街の人々が目にする力強く大胆な，新たなるランドマークを提案した。

人々でにぎわうコートヤードが社交的アクティビティーを活性化し，計画的に配置された交通量の多い主要道路により，臨空SOHO地区と現在の周辺地域，また将来の開発地域が接続される。我々の提案は，主にその形態に関する二つの戦略を中心としている。外部では，連続したバー状の形態のオフィスが波打つようなランドスケープの上に劇的に浮き上がり，内部ではランドスケープから四つの特徴的なコートヤードが掘り込まれるようにしてつくられ，常時にぎわいのあるアクティビティーの場となる。臨空エコノミック・パークのスカイラインに立ち上がる最初の建築となる臨空SOHOは第15地区を周辺の開発地と結びつける地域のゲートであり，アクティビティーの中心となるだろう。

我々の提案は，オフィス棟と波打つ緑化された屋根（グリーン・ルーフ）のつくるランドスケープ，大きなコートヤード，大通りと小さな通り，パーキング，その他のサポート施設からなる。幅18mの細長いオフィス棟には，SOHOオフィスのタイプ1とタイプ2が組み込まれ，両側面に150～300平米の床面積を容易にとることができる。細長いオフィス棟の形態により，全ての部屋に自然光が取り込まれ，極めて快適な空間が実現する。グリーン・ルーフはあらゆる人々の利用できる広大な緑の空間をつくる。東側のコートヤードでは，屋根が地上レベルまで下がっており，屋根の上へとアクセスすることができる。オフィス棟や屋根構造の中にあるオフィスからもグリーン・ルーフの上へとアクセス可能である。グリーン・ルーフを掘り込むようにつくられた四つの特徴的なコートヤードは，多様なパブリックスペースとして機能する。四つのコートヤード同士を繋ぎ，またコンプレックスを周辺の公園と接続する二つの主要な動線軸に加えて，副次的なパスも別の動線を生み出す。

臨空SOHOコンプレックスには東西両面からアクセスする。それぞれのエントランスは，東西軸と南北軸二つの主要な動線に面して開いている。東西軸は，協和路上部のブリッジを通して，第16地区に隣接した展示ホールと南のコートヤードを結んでいる。金錘路からは，建物を12m上部に持ち上げることで生まれた劇的なエントランスから南北軸の動線にアクセスする。この道は二つのメイン軸の交差点にある南のコートヤードに直結している。二つ軸の交差点

には，七つのシアターの入ったエンターテイメント・コンプレックスがあり，臨空SOHOの核として，四つのコートヤードと接続する。

〈四つの動的なコートヤード〉
波打つグリーン・ルーフの下部にはコートヤードがある。構造体が周期的に持ち上がり，コートヤード同士をつなぐと同時に，上昇感のある劇的な空間を生み出している。そのルーフは下がり，最後には地面と一体化する。ランドスケープのようなルーフ上の空間へと人々を導くアクセスとなり，親密なスケールの空間が生まれる。

四つのコートヤードはスケール的に巨大で特徴的なだけでなく，十分な自然光の届く豊かなオープンスペースを生み出している。またそれらの空間は，周囲の商業施設やオフィス，エンターテインメント施設とも関係する。強大なスケールの公共空間の中で，親密ながらもダイナミックな空間を体験できる。

〈サステイナビリティ対策〉
このプロジェクトでは，計画全体を包括するサステイナビリティについての対策を立て，将来の開発モデルとなることを目指した。オフィス棟の細長いプロポーションにより，十分な自然光を取り入れ，人工光による光熱費を削減する。高度なブリーズ・ソレイユ・システムにより，ファサードへの熱負荷を和らげ，エネルギー消費をさらに低減する。巨大なグリーン・ルーフはエネルギー保全においても重要な役割を果たしている。高い断熱性能により熱利得や熱損失を安定化させ，コンプレックス全体を少ないエネルギーで運営することを可能にする。

〈構造システム〉
構造システムは鉄とコンクリートからなる。地階の二つのレベルはコンクリートで，地上より上のレベルの屋根とバー状の建物は鉄からなる。平面計画の効率性と構造性能を考慮し，9 m×9 mのグリッドで構成している。

〈一体的なアプローチ〉
この計画の中で，臨空SOHOコンプレックスは，エコノミック・パークへのアイコニックなゲートとしても機能する。ダイナミックな内部空間と外部をつくり出すコンプレックスは，国際空港と外環高速，北翟路，周辺のビジネス街を，商業的だけでなく文化的にもつなぐ。優れた接続性とアクセスにより，人々は自然や商業的，また文化的アメニティの多様な混在という豊かで都市的な空間を体験する。プログラムと建築，アーバンデザイン，サステイナビリティ，コンテクストなどのすべての要素が全体の設計に織り込まれ一体化される。このようなアプローチを通じて，臨空SOHOプロジェクトは豊かな都市生活と活気あるアクティビティの核となる。

Kaohsiung Maritime Cultural and Popular Music Center

2010 Kaohsiung, Taiwan, R.O.C.

Establishing a Vibrant Urban Landmark: A Cultural Esplanade Between City and Sea

Building upon Kaohsiung's strong commitment to ecological sustainability and vision for enlightened urban development and growth, our proposal for the Kaohsiung Maritime Cultural and Popular Music Center delivers a dynamic cultural esplanade that connects the city of Kaohsiung to the surrounding ecology of the bay, and gifts to the people of the City a vibrant new destination.

As the largest international commercial port of Taiwan as well as a historically prominent economic, social and cultural city, Kaohsiung serves as an undeniably important link between Taiwan and the rest of the world. To strengthen Kaohsiung's position as a pivotal cultural and economic center, the new development leverages the site's position by creating a broad cultural connective tissue along the edges of the Port of Kaohsiung. This edge, and the permeability of the boundary it creates, mediates between Kaohsiung's urban fabric and a restored natural environment. By doing so, a cultural threshold is created that will attract a diverse audience to the newly created exhibition, performance, production, and public spaces, stimulating possibilities for cultural expression, exploration, and expansion.

Our proposal physically and figuratively dissolves the edge of the site into the surrounding harbor, creating a transitional zone for cultural events. Serving as a stimulant for creativity and cultural production in Kaohsiung, this multifunctional cultural zone, concretized in the new Center, disperses social, cultural, and ecological seeds into the broader urban environment. This strategy actuates Kaohsiung as a flourishing pop music hub of Taiwan, highlights the City's role as a maritime capital, and creates a holistic model for urban sustainability. Formally iconic and programmatically rich, our proposal delivers a vibrant new landmark to Kaohsiung.

Our proposal responds to the specific nuances of the site to integrate the Center seamlessly with the fabric of the city. By restoring the site's natural environment, visitors are provided with new perspectives and experiences of the bay. Our scheme takes advantage of the existing contour of the site by crafting a continuous and undulating three dimensional built and planted landscape form. This form is organized by an esplanade that wraps the site, fully integrating and enhancing the existing characteristics of the bay's edge, joining the western and eastern sides of the bay. Functionally, the esplanade serves as a spine along which the varied amenities of the center are arrayed. A dynamic urban plaza, situated to the North of the site along Seashore Road, provides an iconic point of entry to the Center bridging the cities movement to the esplanade. The urban plaza simultaneously acts as a counterpoint to the city's density. Immediately north of the plaza, by building up mass and volume, the Pop Music museum reinforces the existing street edge, its dynamism and vibrant imagery attracting visitors from the surrounding cityscape. To the south of this plaza, a series of eight lantern theaters as well as an adjacent indoor auditorium animate the edge of the bay, while floating islands of mangrove trees further along Seashore Road dissolve the edge of city. Across the bay, the Maritime Museum is strategically lifted to take advantage of the panoramic vistas of the Port of Kaohsiung. Creating a dramatic and unique performance venue, a 12,000 seat outdoor amphitheater utilizes both the iconic center and the restored natural landscape.

Promoting and Engaging Culture
Access and Circulation

Visitors are provided with two paths of movement along the esplanade. The upper boardwalk provides direct access to the formal theater and concert hall, the smaller theater spaces, and a compilation of smaller retail and concession spaces. From the upper boardwalk, visitors can traverse to the western side of the site to access the elevated maritime museum, open amphitheater, and public green space or if they stay on the eastern portion of the site they can descend to a pier, which extends the boardwalk out to the southern tip of the site. Along the entire length of the upper boardwalk, visitors are afforded expansive views of the sea and dynamic vistas created by the complex.

Visitors can also enter the Center through the lower boardwalk, which serves as a recreational promenade along the bay, where cafes and retail shops open onto the waterfront. This boardwalk is accessed directly from the street level open plaza where pedestrians have point of entry into the popular culture museum for an encompassing overview of the vivid cultural activities that surround them. This lower boardwalk terminates by rising to meet the upper boardwalk at the bridge over the Love River, enabling pedestrians to cross over to the amenities along the western bank of the bay. In the regions where the lower boardwalk is concealed, a service network operates to service the many theaters. This network allows direct loading to the stages and workshops of the theaters, and creates smooth differentiated movement throughout the complex.

Amphitheater

The outdoor amphitheater leverages the existing park to the west. By connecting to the existing park, the new development generates an urban space at the scale of the city. This new park rises over the existing roadway to conceal parking and seamlessly integrate to the amphitheater's lawn seating. The theater faces a stage set on the sea, which can be configured as a proscenium with the city lights as a backdrop, or can open up to offer panoramic views of the city of Kaohsiung.

Maritime Museum

Adjacent to the green space and amphitheater is the maritime museum. Below the museum, the boat lift and ferry concourse generate interactivity between the museum and the port to display the current-day maritime activities of the site. The lifting of the museum above the water and harbor, in conjunction with the expansive window that wraps around the corner of the museum provides a vantage point for surveying the surrounding port, effectually exhibiting the city of Kaohsiung as maritime center of Taiwan.

Pop Music Exhibit Area

The Pop Music Exhibit Area, located off the urban plaza, is a living index of the dynamic and ever changing Taiwanese Pop landscape. Visitors to the museum will enter a dynamic lobby located directly off the urban plaza. From the lobby the visitor will ascend to the upper gallery, which is located on an expansive floor with views of the bay and a unique perspective up the river.

Music Hall

The state-of-the-art music hall features vertical chair lift wagons that can transform the theater from a traditional proscenium or thrust configuration into a standing-room, high-capacity pop concert venue. The dynamism and versatility of this main theater space will serve to highlight both local and international performances, drawing in diverse audiences.

Pop Culture Industry Incubation Center

Adjacent to the music hall are administrative spaces and the pop culture industry incubator center, which houses studio, rehearsal, and recording facilities. The close proximity of these elements creates an exciting continuity between the production of pop culture and the presentation and performance of it. Rather than isolating the generative elements from the creative products of this cultural hub, the programmatic integration of the two serves to galvanize the Center as a focal incubator for Taiwan's growing popular music industry.

Lantern Theaters

Inspired by the Kaohsiung Lantern Festival, eight smaller lantern theaters become active performance spaces while docked to the upper boardwalk. These lantern theaters which can simultaneously express the edge condition of the site and serve as extensions of the incubator and main theater, can be uncoupled from the main structure to float freely in the bay. Accessible from visitor and service lobbies, the theaters provide the potential for gallery exhibitions, fashion shows, smaller music performances, debuts, and receptions. As floating venues, these theaters act as migratory event spaces, using the river as a natural setting to bring high quality performance and exhibitions to local areas of the city. These floating venues act as a cultural seeding element, further integrating the new Center into the fabric of Kaohsiung.

An Integrated Approach

Through thoughtful intervention and creative development, the Kaohsiung Maritime Cultural and Popular Music Center will capitalize on this unique opportunity to transform the historic perception of the river. The complex transforms what was barrier into an experience of the waterways as conduit or connective tissue that links together disjointed parts of the city, not only through commerce, but also culture.

This increased connectivity and accessibility enables the development of an armature for a rich and inclusive urban experience that provides inhabitants of the city with a diverse mix of natural, civic and cultural amenities. All of these objectives are interrelated and realized in a design that will achieve a complete integration of program, architecture, urban design, sustainability and context all woven into a seamless whole. This integrated approach to the Kaohsiung Maritime Cultural and Popular Music will establish the Port of Kaohsiung as a vibrant nucleus of popular culture production and exchange while highlighting Kaohsiung City's role as the maritime capital of Taiwan.

都市に活気あふれるランドマークをつくる：街と海の間の文化的遊歩道

高雄市の，進歩的な都市発展／成長へのヴィジョンと環境的なサスティナビリティに対する強い意識に基づいて，我々は高雄海洋文化・ポップミュージックセンターを提案する。それによって，高雄の街を入り江周辺の自然環境に連続させ，街の人たちが行きたいと思う生き生きとした場所を提供

する，ダイナミックな文化的遊歩道をつくり出す。

　高雄は，台湾最大の国際商業港湾であり，またこれまでの歴史においても，抜きん出た経済，社会，文化都市であり，台湾と世界の重要な結節点となっていることは疑い得ない。このきわめて重要な文化，経済の中心という地位をより強めるため，新しい開発は，高雄港のエッジに沿って広範かつ文化的な「結合組織」を形成しつつ，この敷地の価値を高めていく。このエッジとそれが生み出す浸透性のある境界が，高雄の都市ファブリックと取り戻された自然環境の間を仲立ちする。そうすることにより，文化に対するきっかけが生まれ，様々な人々を，新しくつくられた展示，パフォーマンス，創造の場や，パブリック・スペースに惹き付ける。そして，表現することや探究すること，文化を拡張することの可能性を高める。

　我々の提案は，敷地境界を物理的にも象徴的にも周りの港の中に溶かしてゆき，文化的な出来事のために移り変わっていくエリアをつくり出す。高雄の創造力と文化的な成果に対する起爆剤となるべく，この新しい施設で具現化される多機能な文化エリアによって，社会的かつ，文化的，環境的な種子が，より広範な都市環境の中に散りばめられることになる。この戦略は，高雄を活況を呈する台湾ポップスのハブにし，この都市が持つ海洋的な中心地としての役割を強める。そして，都市の持続性に対する総体論的なモデルをつくり出す。形態的にアイコニックで，豊富なプログラムを持つこの提案は，活気あふれるランドマークを高雄に生み出すことになる。

　織物としての都市に，このセンターをシームレスに統合するため，敷地特有の微妙なニュアンスに応答していく。土地の自然環境を復元することによって，ここを訪れる人は，新しい入り江の眺め，新たな体験を得ることができる。既存の地形を利用し，連続的で波打つ三次元的な建築の姿と植栽されたランドスケープの形を，丁寧につくっていく。この形態は敷地を取り囲む遊歩道によって構築され，入り江のエッジが持っている特性を統合し，強め，入り江の東側と西側を結びつけることになる。機能的には遊歩道は，それに沿ってセンターの様々な利便施設が配置される背骨となる。海岸沿いの道路に面する，敷地北側のダイナミックな広場は，センターの入口として，都市の活動が遊歩道と繋ぎ合わされる記号的なポイントとなる。同時に，この広場は都市の密度に対して，対照的なポイントともなっている。広場のすぐ北には，ポップス・ミュージアムのヴォリュームとマッスが建ち並び，既存道路の輪郭とそのダイナミズム，力強いイメージを強調している。それは，訪れる人を周囲の都市景観からこの建物に惹き付けている。広場南側には，8つのランタンのような劇場が連なり，隣接する屋内のオーディトリアムとともに，海際を生き生きとさせる。一方，海沿いの道路の横にはマングローヴ林の浮島が広がり，街の輪郭を滲ませている。高雄港のパノラマを楽しむため，湾に沿って海洋博物館が持ち上げられることが効果的に作用する。ダイナミックで独特なパフォーマンスのための場をつくるため，12,000席の屋外円形劇場は，アイコニックなセンターの建物と，復元された自然景観の双方を上手く利用する形になっている。

文化を推し進め，関わっていくこと

〈アクセスと動線〉
来訪者が遊歩道を巡るには，二つの経路がある。上のデッキ張りの経路を通れば，フォーマルな劇場とコンサートホールに直接至り，また幾つかの小さな劇場スペースやショップ，売店ゾーンに行くこともできる。この道は敷地を横断して，持ち上げられた海洋博物館や屋外円形劇場，パブリックな緑地がある，西側のゾーンに到達する。また，ボードウォークが敷地南端まで延びている埠頭に下りて，そのまま東ゾーンに留まることもできる。この上側の経路全体で，人々は海に広がる眺望と，複合的な建物がつくり出すダイナミックなシーンの展開を楽しめる。

　人々は，下側の板張りの経路を通ってセンターに入ることもできる。これは海沿いの楽しい遊歩道であり，ウォーターフロントに対して開いたカフェやショップが設けられる。ポップ・カルチャー・ミュージアムへの歩行者用の入口がある，道路レベルのオープンな広場から，この経路に行くことができる。ミュージアムでは，人々を取り巻く生き生きとした文化的なものごとを総覧することができる。この下側の経路は最後には，愛河に掛かる橋のところで上側の経路と合流するために登っていく。橋を渡れば，人々は入り江の西岸にある諸施設に行くことができる。下側の経路の見えない部分では，多くの劇場スペースのバックヤードのネットワークが処理される。このネットワークにより，舞台や劇場の作業スペースに直接荷物を運び入れることができ，施設全体で様々な異なる活動がスムーズに行われることになる。

〈円形劇場〉
屋外の円形劇場が，西側にある既存の公園の価値を高める。公園との接続によって，この新しい開発は，街のスケールで都市空間をつくり出すことになる。新しくつくられる公園は，駐車場を隠すように，道路の上に起伏していて，円形劇場の客席の芝生とシームレスに繋がっている。劇場は，海上につくられた舞台を持ち，背景に街の灯りのあるプロセニアムを構成して，高雄市街を一望のもとに眺めることができる。

〈海洋博物館〉
緑地と円形劇場の並びに，海洋博物館がある。博物館の建物の下部には，船舶昇降機とフェリー乗り場があり，博物館と港の対話を生み出し，この場所における現代の海洋的活動を表出している。建物は，港の水面の上に持ち上げられ，コーナーに広大な開口を設けることで，港を見渡すビューポイントをつくり出す。それによって，高雄市を台湾における海事の中心地として効果的に展示することになる。

ポップ・ミュージック展示エリア

街に近い広場の横に配置されるポップスの展示エリアは，ダイナミックで常に変わっていく台湾のポップスの状況を指し示す，活気あるインデックスとなる。人々は広場から躍動感溢れるロビーに入っていく。ロビーからは，川の上に広がる独特の眺めと入り江の風景が見える，広々としたギャラリー階に上がる。

〈音楽ホール〉
この最新式の音楽ホールは，移動式客席用リフトを備え，伝統的なプロセニアム形式やスラスト形式から，ポップスのための大人数収容スタンディング・ホールに変化させることができる。このメイン・ホールのダイナミックさと可変性は，多様な観客を引き込み，地域的と国際的のどちらの演奏においても，それをより良いものにする。

〈ポップカルチャー産業インキュベーション・センター〉
音楽ホールに隣接して，管理事務スペースとポップカルチャー産業インキュベーション・センターがあり，そこにはスタジオ，リハーサル室，レコーディング施設が含まれている。これらの諸機能がホールのすぐ近くに配置されていることで，ポップカルチャーの成果である製品と展示やパフォーマンスの間に，刺激的な連続性がつくり出される。文化的なハブが生み出す成果と，ものを生み出す機能を分離するのではなく，この2つをプログラム的に統合することで，成長産業である台湾のポップス業界の重要な振興拠点としてセンターを活性化する。

〈ランタン劇場〉
高雄ランタン・フェスティバルに刺激を受けて，8つの小さなランタン劇場が，上方にある遊歩道に繋留された船のようにつくられ，活動的なパフォーマンスの場になる。この劇場群は，同時に敷地のエッジを表現しており，メイン・ホールとインキュベーション施設を拡張するようにも使える。これらの劇場は，主構造から切り離して，自由に港に浮かべることができる。人々がアクセスしやすく，サービス・ロビーとも繋がっているので，展覧会場やファッション・ショー，小規模の演奏会，お披露目やレセプションの場としても使用可能である。この劇場群は浮かんでいるので，移動型のイベント・スペースとなり，川を自然の舞台装置にして，良質のパフォーマンスや展示を地域に提供する。この浮遊的な場が文化の種子として働き，新しいセンターは高雄の街とさらに一体化していく。

統合的なアプローチ

このプロジェクトでのユニークな機会を活かし，高雄海洋文化／ポップミュージック・センターは，よく考えられた介入操作と創造的開発によって，河川に対する歴史的認識を変容させる。この複合体によって，水際空間の体験を邪魔していたものが変わっていく。水際空間は，商業ではなく文化によって，バラバラになった都市の各部分を繋ぎ合わせる水路であり「結合組織」なのだ。より繋がりやすく，アクセスしやすくなることにより，自然と街，文化が多様に混じり合った，豊かで総体的な都市的体験を住民に与える骨格が開発されうるだろう。全ての目的は，相互に関係づけられ，デザインとして具体化される。そうして，プログラム，建築，アーバン・デザイン，サスティナビリティ，コンテクストが，全体としてシームレスに織り上げられる，完全なる一体化が実現されるだろう。この建物に対する統合的なアプローチが，高雄の台湾第一の海洋都市としての地位を高め，高雄港をポップ・カルチャーが生み出され交流する，活気あふれる中心地にする。

Site plan

Level 02

1	INDOOR AUDITORIUM / 室內展演空間	
2	OUTDOOR AUDITORIUM / 戶外展演空間	
3	POP MUSEUM / 流行音樂展示區	
4	INCUBATOR / 育成中心	
5	MARINE / 海洋文化展示中心	
6	SMALL THEATER / 小型室內展演空間	
7	FERRY / 渡船站	
8	RETAIL / 零售	
9	ADMIN / 管理	
10	PARKING LOT / 停車	
11	LOBBY / 大堂	
12	POP LOBBY / 流行音樂展示中心大堂	
13	MEZ. LOBBY / 海洋文化中心大堂	
14	THEATER / 劇場	
15	UPPER BOARDWALK / 上層步道	
16	LOWER BOARDWALK / 下層步道	
17	SERVICE CORRIDOR / 服務通道	
18	THEATER SERVICES / 劇場後勤	
19	SEAT STORAGE / 座位儲存空間	
20	INFO / 信息服務中心	
21	STAGE / 舞台	
22	OUTDOOR PLAZA / 室外廣場	
23	PARK / 公園	
24	VIEWING PLATFORM / 觀景平台	
25	ROAD / 道路	
26	COMPLEX CONNECTION BRIDGE / 複合功能鏈接橋	
27	BIKE PATH / 自行車道	
28	BIKE PATH BRIDGE / 橋上自行車道	
29	BOAT LIFT / 水中真船展示	
30	HARBOR VIEWING GALLERY / 港口觀景畫廊	
31	MECHANICAL / 設備空間	
32	TECH / 技術用房	
33	OA. SUPPORT SPACES / 室外展示空間輔助用房	

Sections

Level 03

Service

Public/Retail

Galleries

Performance

Programs

Landscape diagrams

139

Overall view

Aerial view

Night view

Boardwalk

Amphitheater

Boardwalk

Columbia University Medical Center Campus

2010 New York, New York, U.S.A.

Our design proposal for Columbia's College of Physicians & Surgeons' (P&S) strengthens the University's over 250-year legacy as an intellectual and cultural center for the city of New York. Responding to the pragmatic educational and circulation needs, as well as the intellectual and philosophical mission of P&S, our proposal seeks to achieve three primary objectives:

Advance collaborative, state-of-the-art medical education
The scheme envisions a technologically advanced, 21st century educational environment that serves as fertile ground for the exchange of ideas. The education that occurs through casual interaction outside the classroom thus becomes a vital supplement to the learning that occurs in the classroom. Spaces for informal social and intellectual interaction are integrated throughout the campus, to extend the P&S pedagogy of collaboration beyond the classroom and into daily student life.

Establish visual coherence, physical connections, and a world-class identity for the campus
Our proposal ties together the existing collection of buildings into a unified expression, to create a vibrant, coherent campus embedded in the community. A multi-functional connector, known as the C.A.T. Walk (the 'Columbia Arterial Tube' Walk) flows through the campus to link the three project components with the residences and the broader Medical Center. The C.A.T. Walk creates visual continuity for the campus, establishes a distinct identity through its iconic form, and affords safe circulation paths and destinations for students to meet. The scheme respects historic elements, while inserting new cohesive architectural language, to communicate both the P&S respect for tradition and commitment to innovation.

Create a welcoming campus environment
The scheme encourages a healthy and well-rounded lifestyle for students by including inviting spaces for respite, social interaction, exercise, arts and cultural engagement. The new campus spaces are both dedicated to the needs of the students, faculty, researchers who will use them, and sensitive to the needs and desires of the surrounding community. The strategic integration of shared public spaces, such as the Haven Plaza steps and the accessible Auditorium, fosters a positive relationship between the institution and the community.

To achieve these core objectives, our proposal seamlessly integrates the three project components—the P&S Building Entrance, Black Building and Auditorium Renovation, the New P&S Medical Education Building, and the Haven Square Redevelopment—not only with each other, but also with the greater Medical Center campus and the existing urban fabric. Our scheme creates a vibrant, transformative nucleus for the regeneration of the campus and the adjacent

Site plan

Washington Heights community. We envision architecture that stimulates and nurtures creativity, optimism and the highest aspirations for improving human health and contributing to civilized society.

1. P&S Building Entrance, Black Building and Auditorium Renovation:
A Welcoming Campus Gateway
In the spirit of the institution's commitment to openness and connection, the Black Building and Auditorium are symbolically open to the city. Visual transparencies and accessible common and public spaces connect the institution to the physical, social and cultural fabric of its urban context. Our renovation strategy respects historic elements, while inserting new, innovative complementary elements, to communicate both the P&S respect for tradition and commitment to innovation.

At street level, the Black Building and Alumni Auditorium's transparent facade serves as a symbolic "front door" to the campus, inviting the community to observe and to take part in the intensity of activity contained within. To create a bright and welcoming entry befitting the campus, the scheme curates a new entry sequence and approach, with two entry points that share a common glazed entry hall (to relieve the current entry conditions). The West entry to the P&S/Black Building and Auditorium, at the corner of Fort Washington Avenue and 168th Street, opens toward Haven Square. The C.A.T. extends from Haven Square, to become part of the Black building facade. This gesture creates a visual link with the plaza, and reactivates Fort Washington, to reach out towards the Milstein Pavilion and Heart Hospital to the south.

Our stance towards the existing P&S building facade, the first building in the Columbia University Medical College campus, is one of preservation. The P&S facade and archway (no longer used as an entry to the P&S building) are preserved as an instantly recognizable symbol of the school's history.

While responding to its urban context, the renovated Auditorium establishes a distinctive identity for the campus. The perceptual qualities of the Auditorium's facade shift with the changing quality of light over the course of the day; its dynamic, striated skin fluctuates from solid and reflective to shimmering and translucent. The sculpted form of the Auditorium appears to hover over the transparent band of street level glazing. The Auditorium's curved form lifts up, in a deferential gesture towards the P&S building's historic arch. As the raised volume of the Auditorium lifts up, it shelters an open public lobby, with a soaring ceiling that follows the incline of the tiered amphitheater seating above. This lifted volume frames a new East entry to the Auditorium and the P&S/Black building, via the Auditorium's pre-function/lobby space. This secondary entry provides great flexibility for after-hours use of the Auditorium and P&S/Black building. On the ground floor, tucked between the Auditorium and the P&S building, a triple height, skylit campus cafe affords space for students to congregate, study and socialize together.

From the lobby space, a visitor can proceed into the auditorium via three entry points: one at the ground floor lobby area; another at the secondary tier level, up the grand stairs; and via a third level entry lobby at the culmination of the grand stair. The new multi-purpose 622-seat auditorium is designed to accommodate a range of uses, from lectures and classes, to movies and plays, to music and staged events. The auditorium form is expressed on its interior as a singular shape, wrapped in all sides with paneling. The new auditorium conforms to all accessibility requirements. The auditorium's sculpted roof conceals its mechanical equipment, to ameliorate views from the adjacent Black and P&S towers and from the street. The auditorium provides for a nod to the existing armory across it, and serves both as a testament to the history of the old campus as well as a nucleus for the definition of the new campus.

2. Physician and Surgeons Medical Education Building:
A State-of-Art Space that Fosters Collaboration

The new Medical Education building affords a state-of-the-art space that supports the core principles of the new P&S curriculum—a commitment to collaborative group learning and technology-based problem solving. The architecture physically concretizes the P&S mission to not only prepare students to become excellent physicians, but also to empower each student as part of a community helping fellow classmates to become excellent physicians.

The proposal inserts a new beacon of light set among the existing brick towers, its lightness and transparency symbolizing a new attitude toward the local urban fabric and community. The fluid form language and striated facade materials of the new P&S building visually connect to the new Auditorium's architectural language—a language that expresses the P&S commitment to innovation in medicine and a 21st century medical education.

The new P&S Education Building anchors the northern gateway to the campus. The site of the existing communal garden is preserved as open space, and transformed into a re-energized plaza between Bard Towers 2 and 3, to afford an open view corridor towards the Hudson River from 171st Street. The plaza serves as an outdoor portal for both the Education Building and an elevated River Terrace—an elevated garden off the street, with extraordinary views of the Hudson. The new P&S building's dramatic cantilever shelters the plaza, and the undulating C.A.T. creates a fluid canopy that invites students into the plaza and Education Building.

Internally, the building is conceived as a vehicle to foster collaborative learning and a close-knit community among students and faculty. The building program organization and circulation is centered around the life of the medical student. The building's base harbors the social heart of student life: student-centric spaces (such as the auditorium, lecture hall and student support and administration services) are located on contiguous core levels, connected by a grand stair, on the public face of the building. The stair's prominent location displays the activity contained within the building to the street. From the entry lobby, the grand stair leads down a level to the large auditorium and lecture hall, and up to student-centric services on the first through fourth levels. The lobby's floor pulls away from the street, to bringing light and views to the outdoors into the lobby of the lower-level auditorium and lecture hall. The concentration of activity at the building's base allows for impromptu conversations and planned gatherings among students and faculty—the type of informal social interactions that extend the P&S pedagogy of collaboration beyond the classroom and into daily student life.

High-tech learning and clinical simulation spaces, located on levels five through ten,

Axonometric: site

are designed to maximize flexibility and accommodate future advances in technology. Each academic level provides breakout areas and common student spaces, to facilitate collaborative group learning. The anatomy lab is designed as state-of-the-art space with full security, mechanical, and lighting provisions. Located at the cellar level, the lab has easy and secure access to service points below grade. Underground parking connected to Residential towers functions as service entries into the building. The building frames extraordinary views of the Hudson River for students and staff. The administrative offices' balcony overlooks the Hudson, and the student lounge's sky balcony on the eleventh floor, enjoys views out to the Hudson and New Jersey, and down Haven Avenue towards Haven Square.

3. Haven Square Redevelopment:
A Vibrant Social Hub for the Campus

Haven Square becomes a powerful connective device and symbolic heart for the campus as a whole. The redeveloped Haven Square provides vital space for formal and informal University events, while serving as a valuable public amenity for the surrounding community. Both keystone and connector, the plaza encourages social exchange and harnesses flows from the surrounding buildings onto this new campus green space. Located at the hinge point of the campus, the Square links the new P&S building with the Black Building. Like a campus 'quad' with inviting lawns and shade trees, the Square simultaneously reconnects the surrounding University buildings (including the main medical student residences at Bard Hall and the recently renovated Hammer Sciences Teaching and Learning Center) around a locus of activity.

Walking down Haven Avenue from the new P&S building and the residential towers, the pedestrian is drawn towards the Square's green space and stepped groundscape, animated with activity. The grand steps bend around the Square's Central Lawn, toward the Black building, to create a sense of place and to mediate the steep change in elevation. Like Columbia University's Low Library steps, or the Spanish Steps in Rome, Haven Square's grand steps serve as a gathering space for students, faculty, patients, and members of the broader community. The C.A.T., with its hanging ivy gardens, weaves through the Square, to create a sense of enclosure and shade. The C.A.T. Walk becomes an iconic symbol of the campus, and reinforces the linear connection between the Auditorium building, Haven Square and the New Medical Building Education Building. Haven Square thus provides a sense of continuity for the campus, while maintaining access to the relocated Neurosciences Institute parking area located at the south end of the plaza, as well as full emergency vehicle access to areas of the plaza.

In creating a social hub populated with activity, Haven Plaza also expands safety for the university community. Studies have shown that "a ten-percent increase in social capital—whereby the neighbors know each other better and know who is to be trusted—will actually do more for public safety than a ten-percent increase in expenditures for police officers, squad cars... and other conventional 'public safety' measures."

Our proposal for Phase 2 incorporates a potential future pavilion building, which can serve as security offices or as a cafe, based on the needs of the school. Haven Square's constant flow of people and proximity to the 168th St Subway provides an ideal destination for a cafe, which would in turn further activate the plaza. The cafe supports security measures, both as a social hub, and as a vantage point from which personnel can clearly watch both the 168th Street and Haven Avenue axes. The relocation of cafe program area to Haven Square would afford the school an additional 3,000-4,000 square feet of program area in the Black Building or other parts of the campus, to accommodate changing spatial needs. Phase 2 also proposes extending the material language of the new P&S building and Black/Auditorium renovation facades to the future bookstore facade, to forge continuity and identity throughout the campus.

1. P&S Building Entrance, Black Building and Auditorium Renovation

Corner view

Exploded axonometric

1 AUDITORIUM
2 MECHANICAL
3 CAFE
4 MAIN STAIR
5 ENTRY

0 10 25 50 ft

Section

145

First floor

Second floor

1 ENTRY
2 CAFE
3 ASSEMBLY
4 LOCKER ROOM
5 GREEN ROOM

Night view

Assembly

2. Physician and Surgeons Medical Education Building

Exploded axonometric

Entry plaza

Sixth floor

First floor

Basement

Staircase

1 MECHANICAL
2 LARGE LECTURE
3 PREFUNCTION
4 COAT ROOM
5 GREEN ROOM
6 AUDITORIUM
7 MINORITY AFFAIRS CONF.
8 STUDENT AFFAIRS ADMIN
9 LOBBY
10 ENTRY VESTIBULE
11 ENTRY PLAZA/OUTDOOR CAFE
12 CURRICULAR AFFAIRS ADMIN
13 COMMON STUDY AREA
14 PROBLEM BASED LEARNING ROOM
15 STUDENT ADMIN OFFICE
16 TEACHING LAB. CLASSROOM
17 STUDENT LOUNGE
18 CAFE

Sections

私たちがコロンビア大学医科大学院（P&S）のために行った設計提案は、250年に及ぶニューヨーク市の知的・文化的中心として、大学の伝統を一層高めるためのものである。P&Sの知的・哲学的使命と同様、実践教育と相互交流の必要性に応えるために、私たちの提案では三つの主要目標の達成が模索された。

〈先進的な共同研究・最先端医療教育〉
知的交流のための豊かな土壌としての役割を果たす、21世紀における最先端技術の教育環境を構想する計画である。教室の外のくつろいだ交流を通して生まれる教育は、ひいては教室内の学習を補足する上で不可欠なものとなる。社会的・知的交流のためのインフォーマルな空間は、キャンパスへとくまなく統合され、教室を越え、学生の日常生活の中へとP&Sの共同研究を拡張するものである。

〈キャンパスにおける視覚的一貫性、物理的連続性、及び世界クラスの独自性の確立〉
私たちの提案は既存の一連の建築を、ひとつの統一された表現に結びつけ、地域コミュニティの中に活気に満ちた一体感のあるキャンパスをつくり出す。C.A.T.ウォーク（「コロンビア大学中央チューブ」ウォーク）と呼ばれる複合機能コネクタがキャンパスを流れるように走り、計画を構成する三つの部位を、住居棟とより広大な医療センターへと結びつける。C.A.T.ウォークはキャンパスに視覚的連続性を生み出し、その象徴的形態を通して固有の独自性を確立する。さらに学生同士が集まることのできる安全な循環動線となっている。計画では新しく首尾一貫した建築言語を挿入するとともに、歴史的要素に敬意を払うことで、P&Sの伝統に対する尊重と、革新への関与をはっきりと表明している。

〈心地よい構内環境の創造〉
計画では、学生が健康で豊かな生活を送れるように、休憩、社会交流、スポーツ、芸術、文化活動のための魅惑的な空間が包含された。新しいキャンパスは、ここを利用する学生や教員、研究者の要求に捧げられるのと同様に、周辺を取り巻くコミュニティの要求や要望に対してきめ細やかに応答する。階段状のヘヴン・プラザや使いやすいオーディトリアムといった公共スペースを共有する統合戦略が、大学機関とコミュニティのあいだの良好な関係を深めている。

これらの核となる目標を達成するために、私たちは計画を構成する3要素――P&S棟エントランス、ブラック・ビルディング及びオーディトリアム改修／新P&S医療教育棟／ヘヴン・スクエア再開発計画――を、お互い同士はもちろん、医療センターの大キャンパスや既存の都市構造へと滑らかに統合されるように提案した。私たちの計画は、キャンパスや隣接するワシントン・ハイツのコミュニティの再生のために、周囲を活気あるものに変えてゆくための核を生み出すことにある。私たちは人間の健康を向上させ、文明社会へと貢献する創造性、楽観主義、及び高尚な目標を、刺激し、育む建築を構想する。

1　R&B棟エントランス、ブラック・ビルディング、オーディトリアム改修
〈心地よいキャンパスの表玄関〉
開放性と連続性への関与という大学機関の考え方に沿って、ブラック・ビルディングとオーディトリアムは、象徴的に、都市に対して開かれている。視覚的透明性とアクセスの容易な共通の公共空間は、都市的文脈における物理的、社会的、及び文化的構造体を大学機関に結びつけている。私たちの改修戦略は新しい、革新的・現代的要素を挿入する一方、歴史的要素に対して敬意を払うことで、P&Sの伝統への尊重と革新への関与を共にはっきりと表明している。

ブラック・ビルディングと同窓会オーディトリアムの透明ファサードは、キャンパスへの象徴的な「フロントドア」として、通りから内部の熱心な活動を見て参加することができるように、地域コミュニティを魅了する。キャンパスに相応しく、明るく心地よいエントランスをつくり出すために、計画では新しいエントランス動線が設けられ、（現在のエントランスの状態を改善するために）二つの入口がガラス張りの一般用エントランスホールを共有している。P&S／ブラック・ビルディング／オーディトリアムへの西エントランスはフォートワシントン・アヴェニューと168ストリートの角で、ヘヴン・スクエアに対して開放されている。C.A.T.はヘヴン・スクエアから延伸して、ブラックビルディングのファサードとなる。このような演出がプラザとの視覚的結合を生み出し、フォートワシントンを再生するとともに、南はミルスタイン病院と循環器科病院まで延伸している。

P&S棟の既存ファサードに対する私たちのスタンスは、コロンビア大学医学部キャンパスで最も古い建築として保存するというものであった。P&S棟のファサード（P&S棟へのエントランスとしてはもはや使用されていない）とアーチは、見てすぐに分かる大学の歴史的シンボルとして保存される。

都市的文脈に応答する一方、オーディトリアムの改修ではキャンパスに固有の独自性を確立する。1日を通した光の変化と共に、オーディトリアムのファサードの認識論的性格も変化する。躍動的な線条の外皮は、形をなくして波のように揺れ動き、半透明の煌めきと共に反射する。オーディトリアムの彫塑的形態は、通りに面した透明なガラスの帯の上に、浮遊するかのように見える。オーディトリアムの曲面形態はP&S棟の由緒あるアーチに向けて、敬意を払うかのように立ち上がる。背の高いオーディトリアムのヴォリュームが立ち上がり、開放された公共ロビーを包み込む。その抜けるように高い天井は、上階の円形劇場の階段状の客席の傾斜をなぞる。この宙に浮くヴォリュームは、オーディトリアムのホワイエ／ロビーを通して、オーディトリアムとP&S／ブラック・ビルディングへの新しい東エントランスを構成している。このサブエントランスのおかげで、オーディトリアムとP&S棟／ブラック・ビルディングは時間外であっても自由に利用することができる。地上階では、オーディトリアムとP&Sビルディングの間に挟まれて、天窓のある三層の高さのキャンパス・カフェが、学生が集まり、勉強し、グループ活動のできる空間を内包している。

ロビーからは、来館者は3つの入口を通ってオーディトリアムへと入ることができる。すなわち、第一に地上階のロビーエリア、第二に大階段を上がった2階、そして大階段の終わりにある3階のエントランスロビーを通してである。新しい622席の多目的オーディトリアムは、講義や授業、映画や演劇、あるいは音楽やステージイベントといった幅広い用途に応じて設計されている。ひとつに仕切られ、全ての面がパネルによって覆われた内部空間は、オーディトリアムの外形の反映である。新しいオーディトリアムは、あらゆるアクセシビリティ上の要求を満たしている。オーディトリアムの彫塑的な形の屋根は機械設備を隠し、隣接するブラック・ビルディングやP&Sタワー、さらに通りからの景観を改善している。オーディトリアムは通りの反対側にある、既存のアーモリー・ビルに敬意を払い、新しいキャンパスを定義する核としての、また旧来のキャンパスの歴史を証明する

P&S Building Entrance, Black Building and Auditorium (left) and Haven Square (right)

2　医科大学院医療教育棟
〈共同研究を促進する最先端の空間〉
新しい医療教育棟はP&Sの新カリキュラムの核となる原則——共同研究授業の実行と，医療技術に基づく問題解決という責任——を支援する最先端空間を内包している。優秀な医師になるための準備を学生にさせるばかりではなく，各々の学生がコミュニティの一員として仲間のクラスメートと助け合うことで優秀な医師になれるようにする。この建築はP&Sのそのような使命を物理的に具体化するものである。

これは既存の煉瓦の高層建築群の中に新しい光の灯台を挿入する提案である。その明るさと透明性は，地域の都市構造とコミュニティに対する新しい考え方の象徴である。新しいP&S棟の流体的な形態言語と線条のファサードの素材は，新オーディトリアムの建築言語——薬学と21世紀の医療教育における革新に対するP&Sの関与を表現する言語——と視覚的に結びついている。

新しいP&S教育棟はキャンパスの北エントランスゲートにしっかりと位置している。既存のコミュニティパークの敷地はオープンスペースとして保存され，バードタワー2及び3のあいだのプラザとして姿を変え，再生される。そこには171ストリートからハドソン川をよく眺めることのできる回廊が内包されている。プラザは教育棟と，高く聳えるリバーテラス——ハドソン川への眺めがとてもよい，通りから離れた空中の庭園——の双方への屋外エントランスの役割を果たしている。新しいP&S棟の大きなキャンチレバーはプラザを覆い，波打つようにうねるC.A.T.は流体的な形状の庇をつくり出し，学生をプラザや教育棟へと導いている。

この建築の内部は，学生と教員のコミュニティの結束力を強め，共同研究を促す媒体として構想されている。建築プログラムの組織構成と循環動線は，医学生の生活を中心に考えられている。建築の基壇部は，学生生活における社会活動の中心となる。学生のための空間（オーディトリアム，講義ホール，学生サポートセンター，事務サービス）が，建築を代表する顔として，大階段へと連続するコア階に隣接して位置しているのだ。階段の配置はよく目立つので，通りからは建築内部の活動を見ることができる。エントランスロビーから大階段を1層降りると，大オーディトリアムと講義ホールへと導かれる。また，4層上がった階に学生のためのサービスエリアがある。ロビーのフロアは通りから離れているため，低層部のオーディトリアムと講義ホールのロビーには光と，屋外への眺めがもたらされる。学生と教員の即興の会話や定期ミーティングなどを考慮して，学生の活動は建築の基壇部に集中している——一種のインフォーマルな社会交流が，P&Sの共同研究教育を，教室を越えて日常の学生生活へと拡張する。

5階から10階に配置された，先端技術の学習や臨床シミュレーションのための空間は，フレキシビリティを最大限確保し，将来の技術発展に適応することができるように設計されている。各々の研究階には共同グループ研究を促すために，小会議室エリアと学生のためのコモンスペースが配置されている。解剖学研究所は，完全セキュリティ，機械設備，及び照明設備とを備えた最先端の空間として設計されている。この研究所は地階に配置されているため，簡単かつ安全に地下のサービス拠点にゆくことができる。住居棟へと連続する地下駐車場は，建物へのサービスエントランスとして機能している。また，建物はハドソン川の素晴らしい眺望を学生と職員に提供する。事務管理室のバルコニーからはハドソン川を見下ろすことができる。また，11階にある学生ラウンジのスカイバルコニーからは，ハドソン川を越えてニュージャージーの町並みを，また，下に目をやるとヘヴン・スクエアに向かうヘヴン・アヴェニューを見て楽しむことができる。

3　ヘヴン・スクエアの再開発
〈活気あるキャンパスの社会的拠点〉
ヘヴン・スクエアは強靭な接続装置であるとともに，キャンパス全体を象徴する中心的存在となる。ヘヴン・スクエアの再開発は，周辺のコミュニティに価値ある公共的快適性をもたらす一方で，公式・非公式の大学のイベントのために活気溢れる空間を提供している。プラザは社会交流を促し，この新しいキャンパスの緑の空間に周囲の建築からの人の流れを結び付ける。いわば要石であり，接合具なのだ。キャンパスのヒンジ部に位置し，スクエアは新しいP&S棟をブラック・ビルディングとつないでいる。キャンパスの「中庭」が芝生と陰をつくる樹木をもたらすように，このスクエアは同時に（バードホールの医学生用本宿舎と，最近改修されたハンマー科学教育学習センターを含めた）大学の周辺施設を，活動拠点の周りへ再び結合させる。

新しいP&S棟と住居棟からヘヴン・アヴェニューを歩いてゆくと，歩道がスクエアの緑の空間に向かって引かれ，学生活動で彩られたグラウンドスケープへと足を踏み入れる。大階段がスクエア中央の芝生の周りをブラック・ビルディングに向かって折れ曲がり，場所性を生み出し，高さ方向の急激な変化を調停する。コロンビア大学のロウ図書館の階段のように，あるいはローマのスペイン階段のように，ヘヴン・スクエアの大階段は，学生や教員，患者，そしてより広汎のコミュニティの住民が集まることのできる空間としての役割を果たす。C.A.T.がツタの生い茂る庭園のあるスクエアを縫うように進み，緑に囲まれた木陰のような雰囲気をつくり出す。C.A.T.ウォークはキャンパスを象徴するアイコンとなり，オーディトリアム棟，ヘヴン・スクエア，及び新医療教育棟との間の直線的関係性を補強する。ヘヴン・スクエアはそれゆえ，緊急車両のプラザエリアへの完全なアクセスや，プラザの南端に位置するよう再配置された神経科学研究所の駐車エリアへのアクセスを保持しながらも，キャンパスに連続性を生み出している。

活発な学生活動の社会的拠点とするために，ヘヴン・プラザではまた，大学コミュニティの安全性が高められた。研究によると「社会資本の10％増加は——隣人がお互いをよく知り，誰を信頼すべきかを知るようになるならば，警察官やパトロールカーのための10％の支出増加といった他の通常の『社会的安全』対策よりも，実際には社会の安全性に数字以上に寄与する」ということが明らかになっている。

第二期に向けた私たちの提案では，大学の要求に併せて防犯事務所か，もしくはカフェとして利用するために，将来的に小規模建築を計画する可能性が含まれた。ヘヴン・スクエアは人の流れが途切れることなく，168ストリートの地下鉄駅からも近い。カフェにとっては，プラザにさらなる活気をもたらす理想的な場所である。社会的拠点として，また，168ストリートとヘヴン・アヴェニューの交差点を職員がしっかりと見張ることのできる見晴らしのよい場所として，カフェは防犯対策を支えることができる。カフェのプログラム・エリアをヘヴン・スクエアへ変更することで，3,000〜4,000平方フィート（約900〜1,200平米）のプログラム・エリアの余裕をブラック・ビルディングやキャンパスの別の場所につくり出し，変化する空間的要求に適応できるようになる。第二期計画では同時に，新P&S棟とブラック／オーディトリアムの改修ファサードの素材言語を，将来の書店のファサードにまで延長し，キャンパスにくまなく連続性と独自性を打ち立てることを提案している。

Looking Physical and Surgeons Medical Educational Building over Haven Square

3. Haven Square Redevelopment

Second floor

Exploded axonometric

0 10 25 50 ft

First floor

1 MAIN PLAZA
2 UPPER PLAZA
3 ENTRANCE
4 CAFE
5 CAFE SERVICE AREA

Cornell University, Computing and Information Science Building

2010-14 Ithaca, New York, U.S.A.

Our design for the new Computing and Information Science Department at Cornell University responds to the Department's mission to:
- Unite the students and faculty of the Computing and Information Science department within a single building;
- Foster an innovative, inspirational and collegial learning environment;
- Provide a physically and mentally healthy work and study environment;
- Express and reflect the Department's educational mission and its unique character within the Cornell Campus;
- Ensure accessibility to the Campus community as well as those in the broader community.

The design is comprised of several key components:

The Entry Plaza
A new elevated Entry Plaza located on the first floor level re-energizes the corner of Hoy and Campus Road. An accessible ramp connects Campus Road to the elevated Entry Plaza and a stair entry facing Hoy Field marks the primary entry into the new building. Protected from the weather by the building above, this new Entry Plaza combines softscape, hardscape and site lighting to creating an outdoor, public and social space. The first floor houses student-centric administrative spaces including spaces devoted to student services as well as the public. These program components benefit from the direct connection to the main lobby, providing access to a Seminar Room, Conference Rooms, Dean's Suite, Student Service's Suites, Finance and IT Suites.

The South Courtyard
An exterior, south-facing courtyard located on the ground floor level opens up into the new building via an atrium, connecting the Lecture Hall foyer with the landscaped campus exterior. This courtyard, in turn, connects to Hoy Field through an accessible ramp providing generous daylighting into the building. This courtyard is flexible in its function; it provides break-out areas for the Department and Cornell sponsored Lecture Hall events, and also provides a new outdoor, study area, or a new, social gathering space encouraging students, faculty and visitor interaction. In addition to the Lecture Hall, instructional laboratories, tutoring spaces and undergraduate lounges are also located on this floor.

The Floating Bar
The second, third and four floors will house the bulk of the Computer and Information Science Department. These three floors, architecturally articulated as a "Floating Bar," are designed with high-efficiency in mind. The exterior assembly combines an unitized, curtain wall system with a vertical, panelized metal fin system that provides shading while allowing for daylight penetration and exterior views.

The second floor is primarily devoted to the Information Science Department with research laboratories and PhD offices located at the building perimeter. These student dedicated spaces are located at the exterior, allowing for space flexibility at the building perimeter. A similar spatial organization occurs at the third floor. The two upper floors will be primarily dedicated to the Computer Science Department. Additional laboratory spaces, offices, PhD offices, lounges and conference rooms are located on these two floors. A main lounge space is expressed on the exterior building form providing for additional cover and protection to the entrance below.

The Atrium
An enclosed central atrium space located near the west end of the building is not only a key element of the project's spatial organization but is also a key feature of the building's design.

The atrium serves as the social heart of the building. This vertical space connects all five floors of the building and reveals a nexus of activity from adjacent conference rooms, lounges, public spaces and circulation spaces. Activated by students and faculty, the atrium provides views across, above and below multiple floors. Natural daylight floods deep into the building through the atrium, lighting up the main entry as well as adjacent connecting spaces. Meeting spaces and collaboration spaces face the interior Atrium, encouraging interdepartmental interaction, and social and intellectual engagement.

Study model: north 1

Stdy model: north 2

Study model: south 1

Study model: south 2

コーネル大学コンピュータ／情報科学部の新棟に対する我々の提案は，以下のような学部の使命に応えるものである。
・コンピュータ／情報科学部の学生たちと教職員を，一つの建物にまとめること
・革新的で，インスピレーションに富む，大学らしい学習環境を整えること
・身体的，精神的両面で，健全な労働／研究環境をつくること
・学部の持つ教育的使命とキャンパス内での個性を反映し，表現すること
・大学コミュニティやさらに広いコミュニティへの繋がりも確保されること

デザインは，以下のように幾つかの大事な要素から構成されている。

〈エントリー・プラザ〉
上部に建物を持ち上げた新しいエントリー・プラザは，建物の2階に位置し，ホイ・ロードとキャンパス・ロードの交差点を再度魅力あるものにする。キャンパス・ロードからはスロープでプラザに繋がり，ホイ球場に面した階段が新棟への主な入口となる。上に建物があるおかげで，新しいプラザは風雨から守られており，屋外の公共的，社交的なスペースをつくるために，ソフトスケープ（植物など）とハードスケープ（石や金属など），ライティングが結合されている。2階には学生が自主的に運営するスペースがあり，市民と学生の両方が利用できる機能も含まれている。これらの機能は，直接メイン・ロビーと接続されることで，セミナー室や会議室，学部長室，学生サービスや金融，ITの諸機能へアクセスすることができる。

〈南のコートヤード〉
地上レベルにある南側の屋外コートヤードは，アトリウムを介して，新しい建物をオープンにしている。これによって，レクチャー・ホールのホワイエは，キャンパスのランドスケープに連続していく。また，コートヤードからスロープによってホイ球場に行くこともでき，建物の中に豊かな日差しを取り入れる。機能的には様々な意味があり，学部や大学が主催するレクチャー・ホールでのイベントの休憩スペースになったり，新しい屋外の研究スペースになったり，学生や教職員，外部からの訪問者が集い，交流する新たな社交的な場にもなる。レクチャー・ホールに加え，教育のための研究室，講習スペース，学部生のラウンジも，このフロアに配置されている。

〈浮遊するバー〉
3〜5階には，コンピュータ／情報科学部の機能の大半がある。この3層は，建築的には「浮遊するバー」として明快に分節され，効率の高さを念頭にデザインされている。外装は，パネル化された垂直フィン・システムと，カーテンウォールユニット・システムが組み合わされる。このフィンは，採光と眺望を確保しながら，日除けの効果を備えている。

3階には，主に情報科学部門の研究室，建物外周部には博士課程の院生室が配されている。これら学生用のスペースは，フレキシビリティを考えて，建物外周部に配置される。4階も同様の空間構成で，上2層は主にコンピュータ科学部門に充てられている。この2層には他に，さらなる研究室や事務室，院生室，ラウンジ，会議室がある。メインのラウンジ・スペースは，下階にあるエントランスをさらに覆い，環境的に守るために，建物の外形に表出されている。

〈アトリウム〉
建物のほぼ西端部に位置する中央アトリウムは，このプロジェクトの空間構成の中心的な要素であるだけでなく，建築デザインのカギとなる特徴的な存在である。

アトリウムは，この建物の社交的な側面での心臓部にあたる。建物の5層全体を上下に繋ぎ，隣り合っている会議室，ラウンジ，パブリック・スペース，動線空間における人々の動きの結びつきを明快に見えるようにしている。学生，教員たちの活発な動きが，複数のフロアをまたぐ上下，それに水平方向の視線の広がりをつくり出す。アトリウムによって自然光は建物の奥まで降り注ぎ，メイン・エントランスとそこからの接続空間にも光がもたらされる。会議室と共同作業室はインテリアでアトリウムに面していて，内部での部局間の交流や，社会的，知的な繋がりが促進される。

Study model: north 3

Study model: west 1

Study model: south 3

Study model: west 2

Perspective

Conceptual diagram: unfolded elevation metal skin

156

Perspective: southwest metal skin

Conceptual diagram: exploded perspective metal skin

157

PROFILE

Thom Mayne
MORPHOSIS

Born in Waterbury, Connecticut, U.S.A. in 1944.
Graduated from Southern California Institute of Architecture (Bachelor of Arch.) in 1968. Received Master of Arch. from Harvard University in 1978.
Established private practice in Los Angeles in 1971 and founded Morphosis, Los Angeles in 1972.
In 1972, he helped to found the Southern California Institute of Architecture. Since then, he has held teaching positions at Columbia, Yale (Eliel Saarinen Chair in 1991), Harvard University, GSD/Graduate School of Design (Eliot Noyes Chair in 1998), Berlage Institute in the Netherlands, and many other institutions around the world. Currently, he holds a tenured faculty position at UCLA School of Arts and Architecture.

With Morphosis, he has been the recipient of the 2005 Pritzker Architecture Prize. Currently, he is leader of Morphosis Architects and holds a tenured faculty position at the UCLA School of Arts and Architecture.

LIST OF PROJECTS

01
GIANT GROUP CAMPUS
(2005-10 Shanghai, China)
Architects: Morphosis Architects—
Thom Mayne, design director;
Tim Christ, Paul Gonzales, project managers;
Hann-Shiuh Chen, Mario Cipresso, Ted Kane, project architects; Leonore Daum, project designer;
Patrick Dunn-Baker with Andrew Batay-Csorba,
Marty Doscher, Graham Ferrier, Chris Herring, Debbie Lin, Kristina Loock, Yichen Lu, Scott Severson, Mohamed Sharif, Suzanne Tanascaux, Chris Warren, project team;
Adam Bressler, Soohyun Chang, Guiomar Contreras, Laura Foxman, Joe Justus, Michelle Siu Lee,
Hugo Martinez, Mark McPhie with Kyle Coburn, Brock Hinze, Sunnie Lau, Greg Neudorf, Christin To, Jose Vargas, Dana Viquez, Mike Patterson, Nutthawut Piriyaprakob, Aleksander Tamm-Seitz, project assistants
Local architect: SURV
Client: Giant Group
Consultants: Bao Ye, Thornton Tomasetti Group, Inc., MAA Engineers, structural; Moh and Associates Inc., design institute; IBE Consulting Engineers, MAA Engineers, electrical and mechanical; Morphosis, interior; SWA Group, landscape
General contractor: China Construction Third Engineering Bureau
Program: headquarters and offices for Giant Group, residence for the Chairman & all Giant Group employees, hotel, training center and clubhouse
Site area: 3.2 ha (7.9 acres)
Total project area: 23,996 m^2 (258,300 sq.ft.)

02
UNIVERSITY OF CHICAGO CENTER FOR CREATIVE AND PERFORMING ARTS
(2006 Chicago, Illinois, U.S.A.)
Architects: Morphosis Architects—
Thom Mayne, design director;
Silvia Kuhle, project manager, Natalia Traverso Caruana, Go-Woon Seo, Aleksander Tamm-Seitz, project designers;
John Carpenter, Guiomar Contreras, Leonore Daum, Graham Ferrier, Penny Herscovitch, Ted Kane, Michelle Siu Lee, project team; Patrick Dunn-Baker with Joe Justus, Michael Sargent, project assistants
Client: University of Chicago
Consultants: Thornton Tomasetti Group, Inc., structural; IBE Consulting Engineers, mechanical and electrical; Auerbach Pollock Friedlander, theater consultant
Program: performing arts and academic building with 3 theaters, auditorium, music practice and rehearsal rooms, visual arts classrooms and studios, lecture hall, and wood, metal, and plaster workshops
Site area: 1.5 ha (3.7 acres)
Total project area: 16,908 m^2 (182,000 sq.ft.)

03
NEW ORLEANS NATIONAL JAZZ CENTER
(2006–08 New Orleans, Louisiana, U.S.A.)
Architects: Morphosis Architects—
Thom Mayne, design director;
Tim Christ, project manager;
Andrew Batay-Csorba, project designer;
Hunter Knight, Go-Woon Seo, Aleksander Tamm-Seitz, project team; Patrick Dunn-Baker with Brock Hinze,
Joe Justus, Duly Lee, Hugo Martinez, Barbra Moss, Greg Neudorf, Benjamin Smith, project assistants
Clients: Strategic Hotel Capital/New Orleans Jazz Orchestra
Consultants: Thornton Tomasetti Group, Inc., structural; Davis Langdon, cost estimator;
Auerbach Pollock Friedlander, theater consultant
Program: performing arts center with 900-seat performance hall, 350-seat studio theater, rehearsal spaces, classrooms, museum, restaurant, and event lobby
Structural system: concrete and steel
Major materials: concrete, steel, glass, custom architectural metal cladding
Site area: 0.6 ha (1.5 acres)
Total project area: 13,935 m^2 (150,000 sq.ft.)

04
PHARE TOWER
(2006-15 La Défense, France)
Architects: Morphosis Architects—
Thom Mayne, design director;
Tim Christ, project principal; Charles Lamy, project director; Matt Grady, project manager; David Rindlaub, project architect; Chandler Ahrens, project designer; Irena Bedenikovic, Patrick Dunn-Baker, Anna Crittenden, Marty Doscher, Graham Ferrier, Brock Hinze, Yasushi Ishida, Hunter Knight, Sunnie Lau, Debbie Lin, Andrea Manning,
Richard McNamara, Aaron Ragan, Stephanie Rigolot, Scott Severson, Benjamin Smith, Satoru Sugihara,
Martin Summers, Aleksander Tamm-Seitz,
Suzanne Tanascaux, Ben Toam, Shanna Yates, project team; Hugo Martinez with Kyle Coburn, Guiomar Contreras, Mauricio Gomez, Joe Justus, Jennifer Kasick, Duly Lee, Michelle Siu Lee, Barbra Moss, Greg Neudorf,
Nutthawut Piriyaprakob, Michael Sargent, Christin To, Jose Vargas, Dana Viquez, project assistants
Consulting architect: SRA Architectes
Client: SCI CNIT Development
Consultants: Setec TPI, structural; RFR Elements, facade consultant and energy modeling; Setec Batiment, IBE Consulting Engineers, HVAC and environmental; AVLS, acoustical; Davis Langdon, Sterling Quest Associates, AEI, cost estimator; Lerch Bates of North America, vertical transportation; Cabinet Casso, code and security
Construction manager: Oger International
Program: commercial office tower with office space, employee restaurants, public cafes and amenities, panoramic restaurant
Site area: 3,420 m^2
Total project area: 164,180 m^2 (1,767,273 sq.ft.)

05
KUALA LUMPUR TOWERS
(2008 Kuala Lumpur, Malaysia)
Architects: Morphosis Architects—
Thom Mayne, design director;
Kim Groves, project manager;
Mario Cipresso, Christopher Warren, project designers/studio shift; Jesus Banuelos, Min-Cheng Chang,
Jon Cummings, Laura Decurgez, Jessica D'Elena,
Penny Herscovitch, Mark Johnson, Hugo Martinez,
Satoru Sugihara, Ben Toam, project assistants
Associate architect: Studio Shift
Client: Sunrise Berhad
Consultants: Thornton Tomasetti Group, Inc., structural; Buro Happold, mechanical
Program: residential suites, boutique hotel, grade A office and signature retail space
Structural system: reinforced concrete, steel
Major materials: concrete, steel, glass,
custom high performance architectural metal cladding
Site area: 0.64 ha (1.6 acres)
Total project area: 107,575 m^2 (1,157,923 sq.ft.)

06
TAIPEI PERFORMING ARTS CENTER
(2008-09 Taipei, Taiwan, R.O.C.)
Architects: Morphosis Architects—
Thom Mayne, design director;
Kim Groves, project principal;
Brandon Welling, project manager;
Aleksander Tamm-Seitz, project designer;
Amy Kwok, Scott Severson, project team;
Jesus Bañuelos, Min-Cheng Chang, Jessica D'Elena,
Alex Deutschman, Penny Herscovitch, Mark Johnson,
Andrea Manning, Hugo Martinez, Michelle Nermon,
Sophia Passberger, project assistants
Consulting architect: J. J. Pan and Partners Architects & Planners

Client: Department of Cultural Affairs, Taipei City Government
Consultants: Buro Happold, Evergreen Consulting Engineering, Ltd., structural; Buro Happold, Hander Engineering Consultants, Inc., MEP; I. S. Lin Engineers and Associates, HVAC; Jaffe Holden Acoustics, Inc., acoustical; Auerbach Pollock Friedlander, theater consultant; Auerbach Glasow French, Originator Lighting Design Consultant, Inc., lighting; Cosmos Inc. Planning and Design Consultants, landscape; RWDI, wind tunnel consultant; Davis Langdon, cost consultant
Program: Opera Hall, Playhouse, Multi-Form Theater, administration, performance service spaces, retail, public plaza, and parking
Site area: 2.0 ha (4.9 acres)
Total project area: 39,124 m² (421,138 sq.ft.)

07
SEOUL PERFORMING ARTS CENTER
(2008–09 Seoul, South Korea)
Architects: Morphosis Architects—
Thom Mayne, design director;
Kim Groves, project principal; Ben Toam, project designer; Elizabeth Wendell with Scott Severson, Josh Sprinkling, Satoru Sugihara, project team; Jesus Bañuelos, Anne Marie Burke, Min-Cheng Chang, Jessica D'Elena, Alex Deutschman, Patrick Dunn-Baker, Penny Herscovitch, Mark Johnson, Andrea Manning, Hugo Martinez, Michelle Nermon, Sophia Passberger, project assistants
Collaborating architect: Chang-Jo Architects
Client: Municipality of Seoul, Seoul Performing Arts Center
Consultants: Buro Happold, structural and MEP; Auerbach Pollock Friedlander, theater consultant; Jaffe Holden Acoustics, Inc., acoustical; Davis Langdon, cost consultant
Program: opera theater and concert hall with supporting areas
Structural system: steel, reinforced concrete
Major materials: steel, glass, concrete
Site area: 5.5 ha (13.7 acres)
Total project area: 34,999 m² (376,737 sq.ft.)

08
PEROT MUSEUM OF NATURE & SCIENCE
(2008-13 Dallas, Texas, U.S.A.)
Architects: Morphosis Architects—
Thom Mayne, design director;
Kim Groves, project principal; Brandon Welling, project manager; Aleksander Tamm-Seitz, project designer; Kerenza Harris, Andrea Manning, Scott Severson, Martin Summers, Jennifer Workman, project team; Jesus Bañuelos, Andrew Batay-Csorba, Amaranta Campos, Kyle Coburn, Jon Cummings, Laura Decurgez, Yusef Dennis, Alex Deutschman, Mauricio Gomez, Hugo Martinez, Jason Minor, Sophia Passberger, Anna Protasevich, Scott Smith, Josh Sprinkling, Satoru Sugihara, project assistants
Consulting architect: Good Fulton & Farrell
Client: Museum of Nature & Science
Consultants: Datum Engineers, structural; John A. Martin Associates, Inc., consulting structural engineer; Buro Happold, MEP; URS Corporation, civil engineer; Terracon Consultants, geotechnical engineer; Talley Associates, landscape; Office for Visual Interaction, lighting; Barbre Consulting, vertical transportation; Jim W Sealy Architects, code consultant; Davis Langdon, cost estimator; Good Fulton & Farrell, sustainability; Access By Design, accessibility
General contractor: Balfour Beatty Construction
Program: museum of Nature and Science with galleries, theater, cafe, store, education, and office programs
Structural system: reinforced concrete tower, structural steel plinth
Major materials: concrete, stones/boulders, structural glazing, glass, GFRC (glass fiber reinforced concrete)
Site area: 1.9 ha (4.7 acres)
Building area: 5,110 m² (approx. 55,000 sq.ft.)
Total floor area: 16,723 m² (180,000 sq.ft.)

Cost of construction: US$ 77.5 million

09
EMERSON COLLEGE LOS ANGELES CENTER
(2008-12 Los Angeles, California, U.S.A.)
Architects: Morphosis Architects—
Thom Mayne, principal-in-charge;
Kim Groves, principal & project manager;
Marty Doscher, director of technology & BIM;
Chandler Ahrens, lead designer; Natalia Traverso Caruana, Aaron Ragan, Shanna Yates, project designers; Brock Hinze, Yasushi Ishida, Scott Smith, Josh Sprinkling, Ben Toam, project team
Development consultant: Robert Silverman
Client: Emerson College
Consultants: Technical Resources Consultants, Inc., architectural specifications consultant; John A. Martin Associates, Inc., structural; Hathaway Dinwiddie Construction Company, pre-construction services; Buro Happold, MEP; KPFF, civil engineer; Horton Lees Brogden Lighting Design, Inc., lighting; Katherine Spitz Associates, landscape; Newson Brown Associates LLC, acoustical; Waveguide Consulting Inc., audiovisual/IT consultant; Arup, code/life safety consultant; Davis Langdon, cost consultant; Davis Langdon, LEED consultant; Haley & Aldrich, geotechnical
Program: educational building
Site area: 0.3 ha (0.8 acres)
Total project area: 11,613 m² (125,000 sq.ft.)

10
KING ABDULLAH PETROLEUM STUDIES AND RESEARCH CENTER
(2008–09 Riyadh, Saudi Arabia)
Architects: Morphosis Architects—
Thom Mayne, design director;
Andrew Batay-Csorba, project designer;
Andrea Manning, Josh Sprinkling, Satoru Sugihara, Martin Summers, Elizabeth Wendell, project team; Jesus Bañuelos, Min-Cheng Chang, Jessica D'Elena, Laura Decurgez, Alex Deutschman, Mark Johnson, Jai Kumaran, Hugo Martinez, Jason Minor, Sophia Passberger, Ben Toam, project assistants
Client: Saudi Aramco
Consultants: Buro Happold, structural and MEP; Coen + Partners, landscape; Pixel Liberation Front, animation
Program: research center, library, exhibit hall, conference and visitor center and amenities
Structural system: reinforced concrete and steel
Major materials: concrete, steel, glass, PTFE, ETFE, GFRC
Site area: 56.3 ha (139.0 acres)
Total floor area: 43,992 m² (473,537 sq.ft.)

11
FOUR TOWERS IN ONE COMPETITION
(2008 Shenzhen, China)
Architects: Morphosis Architects—
Thom Mayne, design director;
Kim Groves, project principal; Ben Toamm, project designer; Linda Chung, Amy Kwok, Rachel Smith, Satoru Sugihara, project team; Andrew Batay-Csorba, Anne Marie Burke, Min-Cheng Chang, Jessica D'Elena, Alex Deutschman, Penny Herscovitch, Mark Johnson, Apoorv Kaushik, Andrea Manning, Hugo Martinez, Taraneh Meshkani, Michelle Nermon, Aleksander Tamm-Seitz, Shanna Yates, Jesus Bañuelos, project assistants
Client: China Construction Bank with China Jianyin Investment Securities
Consultants: Thornton Tomasetti Group, Inc., structural; Buro Happold, MEP and facade consultant; Davis Langdon, cost consultant
Program: office building
Structural system: reinforced concrete, steel frame
Major materials: steel, concrete, glass
Site area: 0.7 ha (1.8 acres)
Total project area: 77,098 m² (829,900 sq.ft.)

12
NEW U.S. EMBASSY IN LONDON
(2009–10 London, U.K.)
Architects: Morphosis Architects—
Thom Mayne, design director;
Kim Groves, principal & project manager;
Chandler Ahrens, lead designer;
Graham Ferrier, Elizabeth Wendell, project designers; Jon Cummings, Josh Sprinkling, project team
Client: United States State Department
Consultants: Olin Partners, landscape; Buro Happold with WSP Flack + Kurtz, SMEP, sustainability and civil engineer; Weidlinger and Associates, Inc., blast engineer; Davis Langdon, cost consultant; Sako & Associates, Inc., security; ARUP Government Projects, Inc., fire, life safety, and code consultant; Schaeffer Acoustics, acoustical; Horton Lees Brogden Lighting Design, Inc., lighting; Van Deusen & Associates, vertical transportation; Mayer Reed, environmental graphics
Program: a consular section including a Grand Hall; a diplomatic area with Glass Dome, Gallery, Multi-purpose room and Main Lobby; and an administrative section with offices, conference rooms, cafeteria, terraces, recreation center and retail. The landscape design presents two new significant public plazas, a consular garden, and a formal courtyard, as well as multiple security measures to safeguard the building and its grounds
Structural system: steel
Major materials: steel, glass, concrete
Site area: 2.0 ha (4.9 acres)
Total project area: 39,999 m² (430,557 sq.ft.)
Cost of construction: US$ 450-550 million

13
TAIPEI POP MUSIC CENTER
(2009 Taipei, Taiwan, R.O.C.)
Architects: Morphosis Architects—
Thom Mayne, design director;
Kim Groves, project manager; Ben Toam, project designer; Hunter Knight, Josh Sprinkling, project team; Yusef Ali Dennis with Kyle Coburn, Yusef Ali Dennis, Alex Deutschman, Legier Stahl, project assistants
Associate architect: JJ Pan and Partners
Client: Department of Cultural Affairs, City of Taipei
Consultants: Fisher Dachs, theater consultant; Jaffe Holden, acoustical
Program: pop music center, retail, live houses, outdoor amphitheater, office space
Site area: 7.5 ha (18.5 acres)
Footprint area: 56,300 m² (606,000 sq.ft.)
Total floor area: 56,300 m²

14
SHANGHAI LINKONG PLOT 15 CONCEPT DESIGN
(2010 Shanghai, China)
Architects: Morphosis Architects—
Thom Mayne, design director;
Kim Groves, principal-in-charge;
Chandler Ahrens, lead designer; Scott Severson, project designer; Josh Sprinkling, Jason Minor, project team; Alex Deutschman, Sabrina Chou, Gavin Gaudette, Jamie Pelletier Youbeen Kim, Jeremy Manger, Eleni Koryzi
Client: SOHO China
Program: retail, 7 theaters (including 1 Imax), office and residential
Site area: 86,164 m² (927,461 sq.ft.)
Total floor area: 329,410 m² (3,545,740 sq.ft.)

15
KAOHSIUNG MARITIME CULTURAL AND POPULAR MUSIC CENTER
(2010 Kaohsiung, Taiwan, R.O.C.)
Architects: Morphosis Architects—
Thom Mayne, design director;
Kim Groves, principal-in-charge;
Ben Toam, lead designer; Jason Minor, Josh Sprinkling, project designers; Youbeen Kim, Marcus Chen, Alex Deutschman, Gavin Gaudette, project assistants
Client: Public Construction Commission
Consultants: David Herd, Buro Happold, MEP; Kathleen Bakewell, Brook Farm Group, landscape;
Program: multi-use facility, pop music theaters, maritime cultural center, pop museum
Site area: 11.89 ha
Total project area: 70,900 m²

16
COLUMBIA UNIVERSITY MEDICAL CENTER CAMPUS
(2010 New York, New York, U.S.A.)
Architects: Morphosis Architects—
Thom Mayne, design director;
Charles Lamy, project principal; Ung-Joo Scott Lee, project manager; Chandler Ahrens, project designer; Patrick Dunn-Baker, Josh Sprinkling, project team; Katsuya Arai, Emily Cheng, Kyle Coburn, Jon Cummings, Alex Deutschman, Penny Herscovitch, Jai Kumaran, project assistants
Associate architect: Perkins Eastman
Client: Columbia University in the City of New York
Consultants: Thornton Tomasetti Group, Inc., structural; Syska Hennessy Group, Inc., MEP; Tripp Umbach, medical planning; James Corner Field Operations, landscape
General contractor: F.J. Sciame Construction Co., Inc.
Program: 3 buildings—"New Physicians & Surgeons Medical Education Building" (including academic space, auditorium and administrative space); "new Haven Square Public Plaza"; Renovation and addition to "Black Building" (including auditorium, lobby renovation, amenities and service)
Structural system: steel
Major materials: steel, concrete, glass
Site area: 91,350 sq.ft.—
14,000 sq.ft., P&S Entrance and Auditorium Renovation;
12,350 sq.ft., New P&S Medical Education Building;
65,000 sq.ft., Haven Square Redevelopment
Total project area: 190,000 sq.ft.—
40,000 sq.ft., P&S Entrance and Auditorium Renovation;
100,000 sq.ft., New P&S Medical Education Building;
50,000 sq.ft., Haven Square Redevelopment)

17
CORNELL UNIVERSITY, COMPUTING AND INFORMATION SCIENCE BUILDING
(2010-14 Ithaca, New York, U.S.A.)
Architects: Morphosis Architects—
Thom Mayne, design director;
Ung-Joo Scott Lee, project manager; Jean Oei, project architect; Alayne Kaethler, Debbie Chen, Go-Woon Seo, Cory Brugger, Matt Lake, Kerenza Harris, Paul Choi, project team; Nicholas Shrier, Yu-Jin Sim, Alan Tai, project assistants
Client: Cornell University
Consultants: Thornton Tomasetti, structural; Syska Hennessy Group, MEP/fire protection; Morphosis Architects with Barton & Loguidice, P.C., landscape
Program: academic building with lecture hall, offices, conference rooms, seminar room, dry labs, and collaborative spaces
Total project area: 9,290 m² (100,000 sq.ft.)

Copyediting
Takashi Yanai and Jules Hartzell: pp.36-45

Translation
Masayuki Harada: pp.36-45, p.11, p.55, pp.88-89, p.101, p.110, pp.150-151
Kei Sato: p.47, p.64, p.67 and p.69, pp.76-77, p.82 and p.85, pp.98-99, p.117
Shumpei Kitamura: pp.124-125, pp.132-133
Editorial department: pp.136-137, p.155

MORPHOSIS RECENT PROJECT
モーフォシス 最新プロジェクト

2010年11月25日発行

企画：二川幸夫
撮影：GA photographers
印刷・製本：大日本印刷株式会社
制作・発行：エーディーエー・エディタ・トーキョー
151-0051　東京都渋谷区千駄ヶ谷3-12-14
TEL.(03)3403-1581(代)

禁無断転載

ISBN 978-4-87140-671-0 C1052